# IN MONET'S GARDEN

JOE HOUSTON,
DOMINIQUE H. VASSEUR,
*and*
M. MELISSA WOLFE

CHARLES STUCKEY

JAMES YOOD

# IN *Monet's* GARDEN
## ARTISTS AND THE LURE OF GIVERNY

cm[a]

COLUMBUS MUSEUM
OF ART
COLUMBUS, OHIO

MUSÉE MARMOTTAN
MONET
PARIS, FRANCE

SCALA PUBLISHERS,
LTD.
LONDON, ENGLAND

First published 2007 by
Columbus Museum of Art
480 East Broad Street
Columbus, Ohio 43215
www.columbusmuseum.org

*in association with*

Musée Marmottan Monet
2, rue Louis-Boilly
75016 Paris, France
www.marmottan.com

4   *and*

Scala Publishers, Ltd.
10 Northburgh Street
London EC1V 0AT
www.scalapublishers.com

Published on the occasion of
the exhibition *In Monet's Garden:
The Lure of Giverny*, organized
by the Columbus Museum of Art
and presented October 12, 2007–
January 20, 2008, at the
Columbus Museum of Art and
February 12, 2008–May 11, 2008,
at the Musée Marmottan Monet,
Paris.

This publication is supported in
part by the Mrs. Richard M. Ross
Publications Fund of the
Columbus Museum of Art.

For the Columbus Museum of Art
Nannette V. Maciejunes,
Executive Director
Christopher S. Duckworth, Chief
Editor

For the Musée Marmottan Monet
Jean Marie Granier, Director
Marianne Delafond, Curator

Text copyright
© 2007 Columbus Museum of
Art, Charles Stuckey, and James
Yood

Design and layout copyright
© 2007 Scala Publishers, Ltd.

Illustrations copyright
© 2007 the copyright holders,
see p. 160

Copyedited by Stephanie Emerson
Designed by pulp, ink.

ISBN: 978-1-85759-500-0

Library of Congress Cataloging-in-Publication Data

In Monet's garden : artists and the lure of Giverny / Joe Houston ...
[et al.].
        p. cm.
    "Published on the occasion of the exhibition 'In Monet's garden:
the lure of Giverny', curated by the Columbus Museum of Art and
presented October 12, 2007/January 20, 2008, at the Columbus
Museum of Art and February 12, 2008/May 11, 2008, at the Musée
Marmottan Monet, Paris"—T.p. verso.
        ISBN-13: 978-1-85759-500-0 (soft cover : alk. paper)
    1.  Painting, American—19th century—Exhibitions. 2.  Painting,
American—20th century—Exhibitions. 3.  Painting, American—French
influences—Exhibitions. 4.  Monet, Claude, 1840-1926—Influence—
Exhibitions. 5.  Monet, Claude, 1840-1926—Homes and haunts—
France—Giverny—Exhibitions. 6.  Giverny (France)—In art—
Exhibitions.  I. Houston, Joe, 1962- II. Columbus Museum of Art. III.
    Musée Marmottan.
    ND210.I56 2007
    759.13074'77157--dc22

                                            2007014767

# Contents

# Foreword

For many years, the connections between the Columbus-born painter Theodore Butler and the great French Impressionist Claude Monet have fascinated us. Butler worked at Giverny, married in succession two of Monet's stepdaughters, and fathered two children whose descendants lived at Giverny and kept alive the great master's legend. Professor Charles Stuckey, one of this catalogue's essayists, recalls an equally fascinating link between our Museum and Monet. During World War I, in January 1916 to be exact, when Butler was in the United States working in New York and visiting his family in Columbus, the New York branch of the esteemed Durand-Ruel Gallery lent six late Monet canvases to the Columbus Gallery of Fine Arts, our Museum's original name. How marvelous it must have been when these important "visitors" came to Columbus.

Today, some ninety years after the Durand-Ruel Gallery's loan, we are thrilled to present *In Monet's Garden,* the publication and the exhibition. Both have been made possible thanks to the loan of eight late Monet works from the renowned Musée Marmottan Monet in Paris, the single largest repository of Monet in the world. For this we extend our gratitude to Jean-Marie Granier, Director, and to Marianne Delafond, Curator,

of the Musée Marmottan for their generosity as lenders and for partnering as a venue for the exhibition. We also wish to thank the Académie des Beaux-Arts of the Institut de France, which oversees the Musée Marmottan, for its willingness to work with us on this exhilarating project.

The Columbus Museum of Art is committed to making the art of Modernism accessible to our visitors, here and abroad, through exhibitions, publications, and national and international loans. *In Monet's Garden* is a great example of this commitment. By using two works from our permanent collection, the great 1918 Monet *Weeping Willow* from the Sirak Collection and a superb 1994 Mark Tansey *Water Lilies*, we confirm not only Monet's influence upon generations of artists who have studied his late paintings but also the significance of his gardens at Giverny upon artists who have visited and worked at this special place.

Many have helped to bring this project to fruition. First and foremost are organizing curators, Dominique H. Vasseur, Curator of European Art and project administrator; M. Melissa Wolfe, Associate Curator of American Art; and Joe Houston, Associate Curator of Contemporary Art, who conceived the idea and collaborated to produce this beautiful and informative exhibition. We thank

Charles Stuckey and James Yood, both of the School of the Art Institute of Chicago, for contributing scholarly and enjoyable essays for this publication.

Projects of this scale are not possible without the support of enthusiastic sponsors. We are indebted to JPMorgan Chase Foundation, in particular Melissa Ingwersen, President, and Jeffrey Lyttle, Vice President, Midwest Region. We thank the Chicago-based Terra Foundation for American Art for their strong and enthusiastic support. We also greatly appreciate the support of the Dispatch Media Group and in particular of Phil Pikelny, Vice President and Chief Marketing Officer The Columbus Dispatch; Vice President, Dispatch Digital. Complementing these leading sponsors were many generous donors. With strong leadership from board members Ellen Ryan, Barbara Siemer, and Ann S. Hoaglin, this group of Museum friends made our vision a reality.

An international exhibition is dependent upon the generosity of many lenders. In addition to our esteemed colleagues at the Musée Marmottan, we wish to thank the Musée d'Orsay, Paris, Director Serge Lemoine and Caroline Mathieu; the Allen Memorial Art Museum, Oberlin, Ohio, and Director Stephanie Wiles; the North Carolina Museum of Art and Director Lawrence J. Wheeler;

Frederic Bouin, New York, New York; the Brauer Museum of Art, Valparaiso University, Valparaiso, Indiana, and Director Gregg Hertzlieb; the Butler Institute of American Art, Youngstown, Ohio, and Director Louis A. Zona; the Hunter Museum of Art, Chattanooga, Tennessee, and Director Robert A. Kret; the Des Moines Art Center, Iowa, and Director Jeff Fleming; the Museum of Art, Rhode Island School of Design and Director Roger Mandle; The Ruth Chandler Williamson Gallery, Scripps College, Claremont, California, and Director Mary Davis MacNaughton; the Montclair Art Museum, New Jersey, and Director Patterson Sims; the Terra Foundation for American Art and President Elizabeth Glassman; the Carnegie Museum of Art and Director Richard Armstrong; Mr. Whitney B. Wendel; Geoffrey Young, Great Barrington, Massachusetts; Sara and John Shlesinger, Atlanta, Georgia; Kevin Bruk, Miami, Florida; Miranda Lichtenstein, Elizabeth Dee, New York, and Mary Goldman Gallery, Los Angeles; Lennon, Weinberg Gallery, New York, New York; Donald Rothfeld, MD; Eric Wolf; Isabel Rose, New York, New York; Bernard and Gwenolée Zürcher; Galerie Zürcher, Paris; Joan Mitchell Foundation and Cheim & Read, New York, New York; Christopher Hamick, New

York, New York; Sheri Levine; A. G. Rosen; and numerous private collectors both in this country and abroad. We also thank Keny Galleries, Columbus, Ohio for their assistance.

As always, it takes a team of dedicated and talented colleagues to realize an important project such as this. Columbus Museum of Art staff members include Rod Bouc, Deputy Director of Operations; Catherine Evans, Chief Curator; Cindy Foley, Director of Education; Melinda Knapp, Chief Registrar and Exhibitions Manager; Greg Jones, Exhibition Designer; Elizabeth Hopkin, Associate Registrar; Jennifer Seeds, Associate Registrar; Jennifer Wilkinson, Curatorial Assistant; and David Holm and Darren O'Connor, Preparators. Christopher S. Duckworth, Chief Editor, oversaw publication of the catalogue with our partner, Scala Publishers.

Claude Monet and his magnificent late paintings continue to fascinate us today as much as ever. In fact, this exhibition illustrates and celebrates the longevity of his artistic impact as well as the lure of his home, the celebrated gardens at Giverny, upon countless artists. It is our pleasure and honor to share this "visit" to such a special place in art.

NANNETTE V. MACIEJUNES
Executive Director
Columbus Museum of Art

8

# Lenders to the Exhibition

ALLEN MEMORIAL
ART MUSEUM, OBERLIN
COLLEGE
Oberlin, Ohio

FREDERIC BOUIN
New York, New York

BRAUER MUSEUM
OF ART, VALPARAISO
UNIVERSITY
Valparaiso, Indiana

KEVIN BRUK
Miami, Florida

THE BUTLER INSTITUTE
OF AMERICAN ART
Youngstown, Ohio

CARNEGIE MUSEUM
OF ART
Pittsburgh, Pennsylvania

DES MOINES ART CENTER
Des Moines, Iowa

CHRISTOPHER HAMICK
New York, New York

HUNTER MUSEUM OF ART
Chattanooga, Tennessee

LENNON, WEINBERG
GALLERY
New York, New York

SHERI LEVINE

WARREN LICHTENSTEIN

MIRANDA LICHTENSTEIN,
ELIZABETH DEE
New York and
MARY GOLDMAN GALLERY
Los Angeles

MONTCLAIR ART
MUSEUM
Montclair, New Jersey

JOAN MITCHELL
FOUNDATION
New York, New York

MUSÉE MARMOTTAN
MONET
Paris

MUSÉE D'ORSAY
Paris

NORTH CAROLINA
MUSEUM OF ART
Raleigh, North Carolina

PRIVATE COLLECTION
New York; Courtesy Mary Boone
Gallery, New York

PRIVATE COLLECTORS
New York, New York

PRIVATE COLLECTORS

ISABEL ROSE
New York, New York

A. G. ROSEN

DONALD ROTHFELD, MD

SARA AND JOHN
SHLESINGER
Atlanta, Georgia

TELFAIR MUSEUM OF ART
Savannah, Georgia

TERRA FOUNDATION
FOR AMERICAN ART
Chicago, Illinois

MUSEUM OF ART,
RHODE ISLAND SCHOOL
OF DESIGN
Providence, Rhode Island

SCRIPPS COLLEGE
Claremont, California

MR. WHITNEY B. WENDEL

ERIC WOLF

GEOFFREY YOUNG
Great Barrington, Massachusetts

BERNARD AND
GWENOLÉE ZÜRCHER

GALERIE ZÜRCHER
Paris

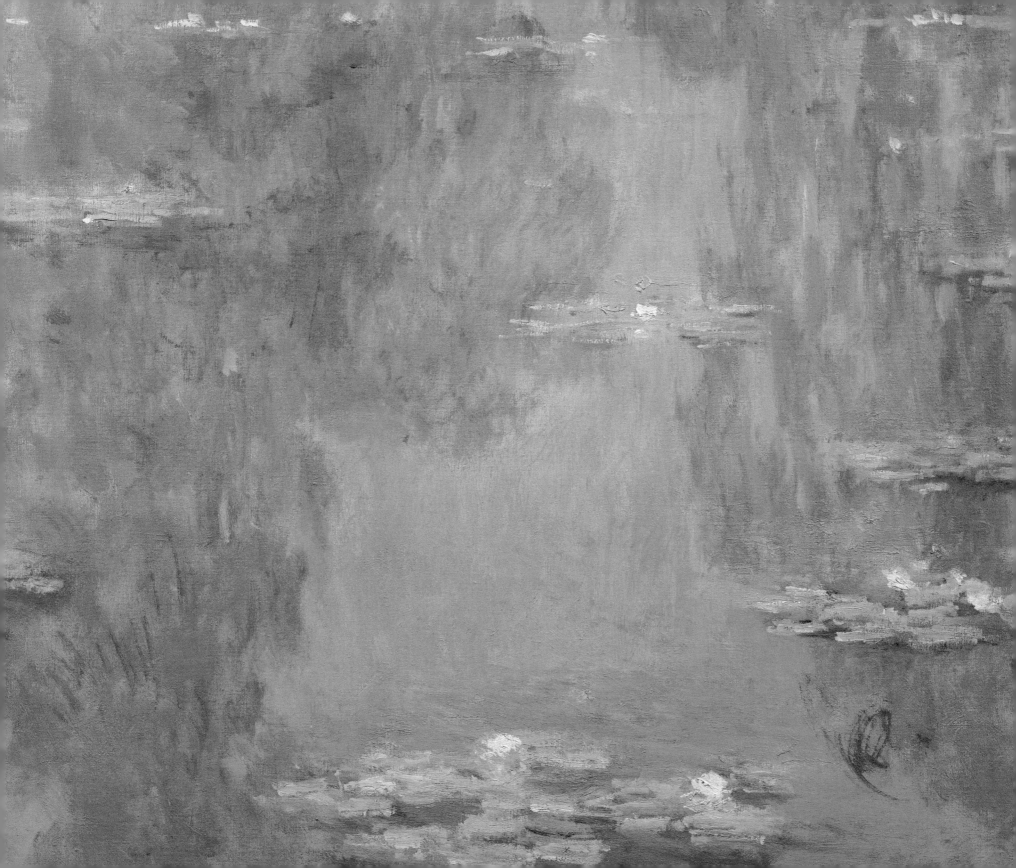

Joe Houston,
Dominique H. Vasseur,
*and*
M. Melissa Wolfe

# THE *Lure* OF *Giverny*

## MONET TO TODAY

SINCE CLAUDE MONET'S REFURBISHED GARDENS WERE REOPENED TO THE PUBLIC IN 1980, millions of visitors, tourists mainly, have made the pilgrimage to Giverny to pay homage to undeniably the greatest and most beloved of the French Impressionist painters. Some of these visitors are artists, and a few lucky ones actually come to live in the town and work there as other painters did a century ago. Now a four-star attraction for art lovers, it is difficult to believe that Giverny once was a sleepy, provincial hamlet. *In Monet's Garden* celebrates the gardens at Giverny as well as the artists who have visited, lived, and worked there.

Gardens, places of beauty, reflection, and regeneration, exist in all countries and cultures. It is little wonder that gardens figure as the beginning and ending places of many of the world's religions. They may be as small and intimate as a backyard or as grand and imposing as those of Babylon or Versailles, manicured and formal with regular pathways and ornamental statuary or romantically lush and playfully wild. While gardens invariably bear the imprint and design of their maker they are always set apart from nature, a separateness enforced by walls, real or symbolic.

opposite (detail)
CLAUDE MONET, **NYMPHÉAS**, 1903; See page 27

fig. 1

**VIEW OF THE MAIN ALLÉE**
1987

Courtesy of Dominique H. Vasseur

More important still, gardens must be nurtured and tended to in order to survive and thrive. Like any living thing, they require constant human attention and often, one could even say, passion.

European artists in particular have painted gardens throughout the ages, from Roman wall frescoes and medieval manuscript illuminations (where the Virgin Mary was compared to the *hortus conclusus*, or walled garden), to the Renaissance. In the seventeenth century, images of nature were favored by the Italians and Dutch, while the French (e.g. André Le Notre) became the world's masters of formal landscape planning. By the eighteenth century, formal gardens were de rigeur, whether attached to royal palaces or private homes. In England, every grand country home had its famed gardens, which provided a palliative effect to the urban business world of major cities like London. In France, variations on semi-tamed nature appear in the dreamy pictures of Antoine Watteau and his *ancien régime* successors as *fêtes champêtres*, country outings.

While the French Revolution briefly did away with such frippery, it was not long until nature took root again under the guise of Romanticism. And when a generation of French artists began to extricate itself from the rigid strictures of the French

12

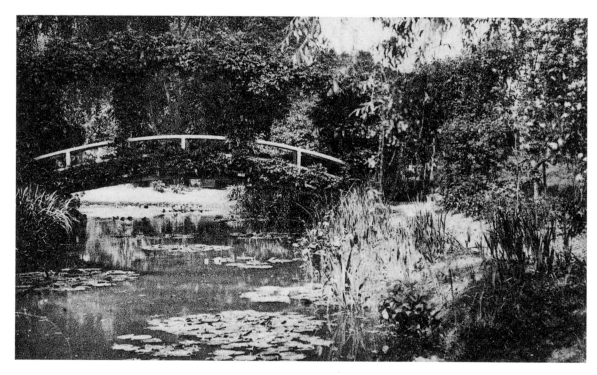

fig. 2
GEORGES ANDRÉ (French, dates unknown)
**GIVERNY (EURE) PROPRIÉTÉ DU MAÎTRE CLAUDE MONET— LE PONT DU JARDIN DES NYMPHÉAS**
(The Japanese Bridge and Water Lily Pond, Giverny)
Undated

Vintage postcard
Courtesy of Musée d'Art Américain Giverny/
Terra Foundation for American Art

Academy, they looked to the landscape as a way out. The painters of the Barbizon School recognized the democratic aspects of nature and their successors, the Impressionists, did as well. These young artists left their studios and plaster casts of classical sculpture for the Paris streets, parks, and pleasure spots. Monet's own journey from Paris to Giverny can be seen in this context as a search for a modern subject that was his and his alone—art made from a garden of his own creation. Just as Impressionism can be seen as a phoenix rising from the ashes of the Tuileries Palace (and Gardens), destroyed in 1871 during the Paris Commune, the apotheosis of this once radical style is clearly found at Giverny. Monet's gardens were a growing, changing, and seemingly endless source of inspiration for the great master and for subsequent generations of artists, among them many Americans.

The story of how Monet came to live at Giverny and create the gardens (figs. 1, 2)—the *parterres* and *allées*, the rose trellises, and the world-famous water garden with its *nymphéas* (water lilies) and Japanese arched bridge—is well documented. Yet, while Giverny's importance to Monet's artistic development and his creativity may be difficult to quantify, its effect is clearly evident through the pictures he painted there from

1883 up to his death in 1926. It is largely through these works that Monet is best known to the world; one picture of water lilies immediately conjures up his name and entire life's work.

Monet, however, displayed interest in gardens long before Giverny and his water lilies. One of his early and important Parisian canvases is of the *Garden of the Princess, Louvre* (fig. 3). Monet, who had received permission to set up his easel on a balcony of the Louvre, painted this small but typically French, manicured *parterre* within the heart of the bustling city of Paris in 1867. The garden's simple geometric shape serves to anchor the lower half of the composition, while its flatness echoes similar treatment found in Japanese woodblock prints. Yet clearly, as Monet shows us, this garden is a place of repose—physical as well as visual, within the heart of the world's most vibrantly modern city.

About this same time, he undertook the now famous *Women in the Garden* (fig. 4), which he painted out-of-doors in the garden of his rented house at Ville-d'Avray, a suburb west of Paris. In order to accommodate the large size of the canvas, Monet had a trench dug and an elaborate rigging system installed so the work could be raised or lowered as he needed. The fact that his

fig. 3
CLAUDE MONET (French, 1840-1926)
**GARDEN OF THE PRINCESS, LOUVRE**
1867

Oil on canvas; 36⅛ x 24 inches
Allen Memorial Art Museum, Oberlin College, Oberlin, Ohio: R. T. Miller, Jr. Fund, 1948.
1948.296

13

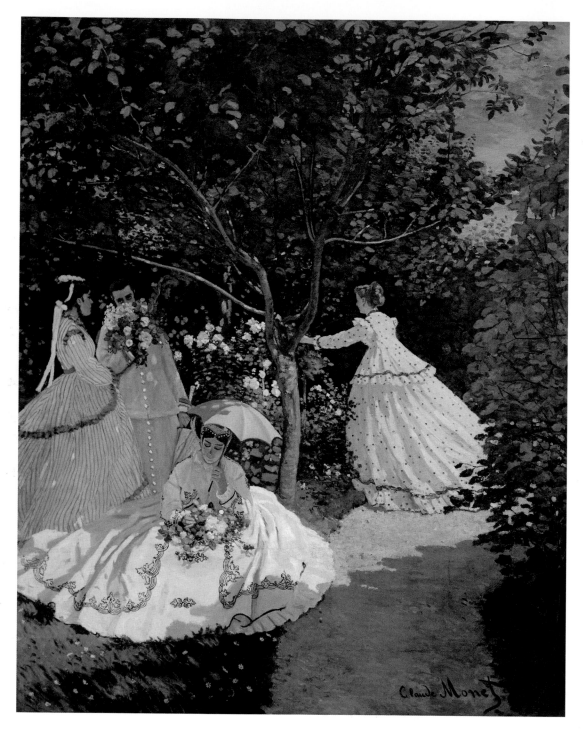

fig. 4
CLAUDE MONET (French, 1840–1926)
**WOMEN IN THE GARDEN**
1867

Oil on canvas; 100 x 81⅞ inches
Musée d'Orsay, Paris

wife, Camille, modeled for all four women may demonstrate his early penury but also shows his admiration and devotion to her. These are but two early works in a lifetime of paintings Monet would create in gardens. Reportedly, Monet said of himself, "I am good for nothing except painting and gardening." He could not have found two more compatible activities.

As he grew more successful, Monet left Paris, and in 1878 he moved to Vétheuil, a town northwest of Paris on the River Seine. At Vétheuil, he painted any number of luxurious garden scenes, such *The Artist's Garden* (fig. 5) from 1880. Five years later, he moved a few miles further downstream to the hamlet of Giverny. About fifty miles from Paris, Giverny would be Monet's last but greatest and most famous residence. Only forty-three when he acquired the property, he amazingly would spend another forty-three years there. Monet truly loved his home and gardens, and although he traveled far from them—to the northern and southern French coasts, to England, Norway, and Italy—he was always eager to return to Giverny where his family, beloved gardens, and artistic inspiration awaited him.

Monet was not alone in finding inspiration at Giverny. The influx of American artists beginning

fig. 5
CLAUDE MONET (French, 1840–1926)
**THE ARTIST'S GARDEN
AT VÉTHEUIL**
1880

Oil on canvas; 59⅝ x 47⅝ inches
National Gallery of Art, Washington, DC:
Ailsa Mellon Bruce Collection.
1970.17.45 (W685)

in the late 1880s attests to the growing popularity of several intersecting trends. During the late 1870s and 1880s, many American artists had begun going to the major European capitals, and specifically Paris, to study with various well-known teachers and at prominent academies—the Académie Julian, the Académie Colarossi, and the École des Beaux Arts, to name but a few. At the same time, while in-studio painting was far from dead, American art students were receptive to the Impressionist battle cry to paint *en plein air*, out of doors. The fashion to painting outside, in nature, was brought to America by the first generation Impressionists who established art colonies in towns like Old Lyme and Coss Cob, Connecticut, and Annisquam, Massachusetts.

By the 1890s Monet was recognized as a major force in modern painting and his home at Giverny was but a brief train ride from Paris. The attraction of meeting with the artist and visiting his gardens mingled with the pleasures of the gentle French countryside proved irresistible to American visitors like John Singer Sargent, Willard Metcalf, Theodore Wendel, Theodore Robinson, and John Leslie Breck. Although by legend unhappy with so many artists knocking at his gate, Monet did allow a few of *les Américains* into his home, his gardens,

and his life. Some, like Breck, he allowed to work at his side; another, Theodore Butler, was even granted permission to marry into the family.

As a member of Monet's favored visitors, Robinson tended to stay away from his compatriots who lived at the Hotel Baudy. Working at Giverny alongside Monet, Robinson was quick to adopt an Impressionist brushwork and palette, which he combined with a flickering, spontaneous brush-work. Nevertheless, while this level of intimacy existed in rare instances like these, the number of Americans who took the train to Giverny merely to visit, to paint, to take a room at the Hotel Baudy, or to rent a home for the summer, was substantially greater.

Some of the later artists who came to Giverny—Frederick Frieseke and Lilla Cabot Perry, for example—rented homes and maintained gardens, presumably in emulation of Monet. Perry favored bucolic scenes of glades, fields, and streams as well as her garden. Frieseke, on the other hand, said, "It is sunshine, flowers in sunshine, girls in sunshine, the nude in sunshine… I know nothing about the different kinds of gardens." Frieseke's interest in gardens was as a feminized setting for a beautiful woman—in a sense a late-nineteenth-century version of the earlier *fête*

15

*champêtre.* His study of light and color is a keen demonstration of an Impressionist creed rooted in a personal optimism and the sheer pleasure of painting more than it is in a rigorous scientific exploration.

These American painters were also bound together in their sense of artistic freedom and discovery. They traveled not only to Giverny, but to Pont-Aven, Brittany, and Grèz, other popular, rural artistic destinations. The group that gathered at Giverny's Hotel Baudy not only painted together and discussed their art, but also dined and drank together, held musical soirées, and read poetry. Some painters were joined by their families, increasing the American presence in this small town. The camaraderie they shared must have been as exhilarating as that of the original French Impressionists when they began leaving their studios to paint outside or to gather at the various cafés that became their favorite haunts. Likewise, for the Americans, this new freedom to paint out of doors was paralleled by the freedom to paint the female figure *au naturel*, something still frowned upon in the United States.

These later visitors to Giverny were also quite aware of other developments in the Parisian art scene. Butler, Frieseke, and Louis Ritman, must

have known that the aims of Impressionism had begun to be questioned by a new generation of artists who felt that painting ought to say less but mean more. The Nabis, a group of young, post-Impressionist, avant-garde artists of the 1890s, in particular, seemed to be offering just such a new voice, and Butler exhibited at least once with these "prophets." Even so, the ties between the Nabis and Monet are there. Pierre Bonnard, the "very Japanese Nabi" moved to Vernon in 1912 and was a frequent visitor at Monet's home. Bonnard's brushwork in particular owes much to late Monet. Butler's, Frieseke's, and Ritman's paintings demonstrate the awareness of a new, modern style by their adoption of a regularized paint application, an emphasis on flat patterns, an insistence on overall composition, and a heightened tonal palette. Although by the end of the nineteenth century Impressionism had outlived its status as a revolutionary art movement, Monet, its leader, remained in full force. Likewise his power as one of the most prolific and influential painters alive was unquestioned.

Following Monet's death in 1926, family members inhabited his house at Giverny, principally Blanche Hoschedé Monet, his stepdaughter. For the intervening decade before World War II,

however, the property was far less a destination for artists and more a private home. In fact, without Monet's near fanatical attention, the gardens gradually fell into disrepair. Canvases left piled against his studio walls sat collecting dust. In essence, the magnetism of the place dissipated. And then came the World War II, which as fate would have it, brought tens of thousands of American soldiers to France. Some of these men and women were or would become artists, and after the war, memories of their experience in France would draw them back. The Servicemen's Readjustment Act, more commonly referred to as the GI Bill, helped finance the college education of many young artists. And France in the postwar period returned to its prominence in Western culture as the leading arbiter of taste in haute couture, cuisine, and music, but perhaps no longer in art. New York, with its influx of European artists during the war, had become the center of artistic change and world leadership. Nevertheless, the sheer wealth and importance of Paris's great museums, cathedrals, and châteaux, provided ample reason to make France the number one tourist destination of the 1950s.

Ellsworth Kelly is perhaps the most famous artist to have studied in Paris at the École des

Beaux-Arts in the late 1940s and 1950s under the GI Bill. His years in France provided him with widely varied experience, from Romanesque art and architecture to Surrealism and a close friendship with Jean Arp. Kelly must have been among the first artists of the second half of the twentieth century to visit Giverny, which was then a much quieter place than today. Kelly, a superb colorist, admits that the late paintings he saw left derelict in Monet's studio must have had an immediate, although perhaps not lasting, effect. The day after his visit to Giverny he painted a completely green canvas, which he appropriately entitled *Tableau Vert.* Remembering the work later, Kelly located it and was surprised to see that he had painted "grass under water," a recurring theme in Monet's water pictures.

Joan Mitchell, a second-generation Abstract Expressionist and personal friend of Kelly, began her expatriate experience in France in the late 1950s. She eventually moved to the town of Vétheuil, second only to Giverny in Monet's life and art, settling on property where Monet lived from 1878 to 1881. A kinship is apparent between the Impressionist master's late pictures and Mitchell's work. Both artists created nature-based paintings though each manages to elude the senti-mentality or picturesque qualities often present in the landscape. Although it would be unfair to see Mitchell's work as in any way an interpretation or imitation of Monet's, there most certainly exists a resonance between the two. Mitchell, who lived in France until her death in 1992, was also aware of the two major events that secured Monet's artistic preeminence in the late twentieth century: Michel Monet's bequest to the French government of dozens of his father's late, previously unknown paintings unveiled at the Musée Marmottan Monet in 1971 and the resurrection of Monet's house and gardens in 1980.

Since the 1980s, the lure of Giverny as a place of artistic pilgrimage has grown by leaps and bounds. The experience once granted to a few dozen artists is now available to millions of visitors from around the world. Through the auspices of philanthropic organizations, Giverny artist residency programs have been funded by the Lila Acheson Wallace Foundation (program active 1977–94), Arts International (active 1978–99), and the Art Production Fund (active since 1999), and a new influx of artists, many of them American, have experienced Giverny in its rebirth. But it is important to recall that this very rebirth is in fact an example of the historicization of the site.

Significantly, there are no Monet paintings on dis-play at Giverny. The house, now refurbished and restored to mirror its appearance in Monet's time, and the gardens, replanted and tended, are in essence a museum to the larger memory of the art-ist and his life. One thinks of other famous French gardens like those at not so far away at Versailles, which have been restored to their seventeenth-century glory. Although the *ancient régime* was swept away in 1789, its ghost lives on in marble, fountains, and ornamental hedges.

Postmodern artists from Mark Tansey onward accept the concept of nature as a philosophical human construction and the world of simulation as an a priori fact. The garden at Giverny can become for them a reconstruction twice-removed, the simulacrum of a mirage. Such skepticism is in-herent to the Postmodern perspective, which leads one to confuse the reproduction with reality and myth with fact. Tansey, in particular, enjoys mining the legends of art history to forge new allegories. In *Water Lilies,* the frozen surface of Monet's pond, disrupted by the influx of roiling waters, becomes a metaphor for the confluence of tradition and modernity, and perhaps a critique of the vain desire to control natural forces. Miranda Lichtenstein, one of a younger generation to discover potent

messages in Giverny, likewise portrays the gardens as a fiction. Her unsettling photographs, eerily barren of tourists, reveal a twilight world of order and disarray. Instead of the sun-filled *allées* and colorfully flowered *parterres,* Lichtenstein's behind-the-scenes views focus on metal stakes, plastic hoses, and other accoutrements necessary to maintain the impression of nature that Monet passionately cultivated. After her stay in France, Lichtenstein traveled to a doppelganger Giverny built in the Japanese countryside, further exploring the blurring of fact and fantasy.

The work of other artists who have lived at Giverny for brief periods, now often through established residency programs, encompass a broad array of approaches from the ironic to the romantic. Will Cotton and Eric Wolf depict the gardens almost secondhand, although both painted directly from life on the grounds or in adjacent studios. Cotton reconstructed the surrounding topography in studio still lifes constructed of pastries, chocolate, and *crème anglaise.* His syrupy *Flan Pond* revels in the sensual surfaces of his confectionary landscapes, a slightly irreverent take on Impressionism. Wolf reduces Monet's classic views of the Japanese bridge and gardens to stark emblems in graphic ink drawings. Unlike most art-

ists-in-residence, Wolf worked *en plein air*, viewing the gardens from Monet's vantage point, working feverishly to capture them in the brief time between visiting hours and sunset. Retaining the essential rhythms of the water, wind, and flora, his renderings have more in common with printed logotypes than Impressionist vistas—nature as trademark. Despite their ironic gaze, Wolf and Cotton both pay homage to Monet and the place he created.

Confronted with the legacy of Monet in his own backyard, some artists fall under the spell of the legendary place. Cameron Martin's meditations on water reflections echo Monet's own fascination with the complexities of light and color. Martin reduces surface and depth to subtly contrasting hues, imparting a timeless quality to the tranquil pond. By contrast, Yeardley Leonard distills the colors of the surrounding landscape into colorful geometries, evocative of Kelly's early abstractions. Paintings such as *In the Garden* convey the light, color, and verdant growth of nature within its dense, syncopated composition. The gardens become a fecund source of a more organic form of abstraction for Alexander Ross and Steve DiBenedetto. Sculpting plasticine models as his guide, Ross amplifies the fantastic

textures and patterns of vegetation and rock. The resulting paintings portray a chlorophyll-rich microcosm of natural processes of growth and decay, a fitting analogy to the calculated environment of Giverny. DiBenedetto finds a consonance between natural processes and the process of painting itself in gestural abstractions harkening back to Mitchell's expressionistic canvases.

The subject of painting and its significant ties to the history of Impressionism is understandably predominant in the contemporary artist's continuing engagement with Giverny. However, video installation artist Mary Lucier captures the rhythms, light, and sound of Monet's house and gardens as no static canvas can. Her nineteen-minute video, *Ohio to Giverny: Memory of Light,* juxtaposes images of the house and gardens with her native Ohio landscape, glorifying the elemental and shifting qualities of light. In a profound twist on the electronic meditation of nature, British artist Dan Hays translates the electronic signals of video back into the medium of painting. Hays's painstaking paintings of Monet's lily pond depict the pixilated image of nature as captured from degraded videotape. Ironically, the electronic "noise" that compromises the image of Giverny in the aptly titled *Deterioration* approaches the visual

frisson of Monet's original canvases. The atmospheric charge of the Impressionists' paintings is replaced by the digital code of electronic transmission. Hays, unlike most of the artists in the exhibition, knows Giverny only through dimensionless images, ascertaining its mysteries from a distance, as do most of us.

Monet's garden at Giverny is many things to many people. Yet despite its status as a tourist destination, for artists in particular, it is and should always be an exceptionally special place. Its lure upon artists, although diminished for a few decades, is again strong. Clearly, the garden that Monet planned, planted, and passionately tended for the last half of his life continues to inspire artists to produce challenging, engaging, and notable results.

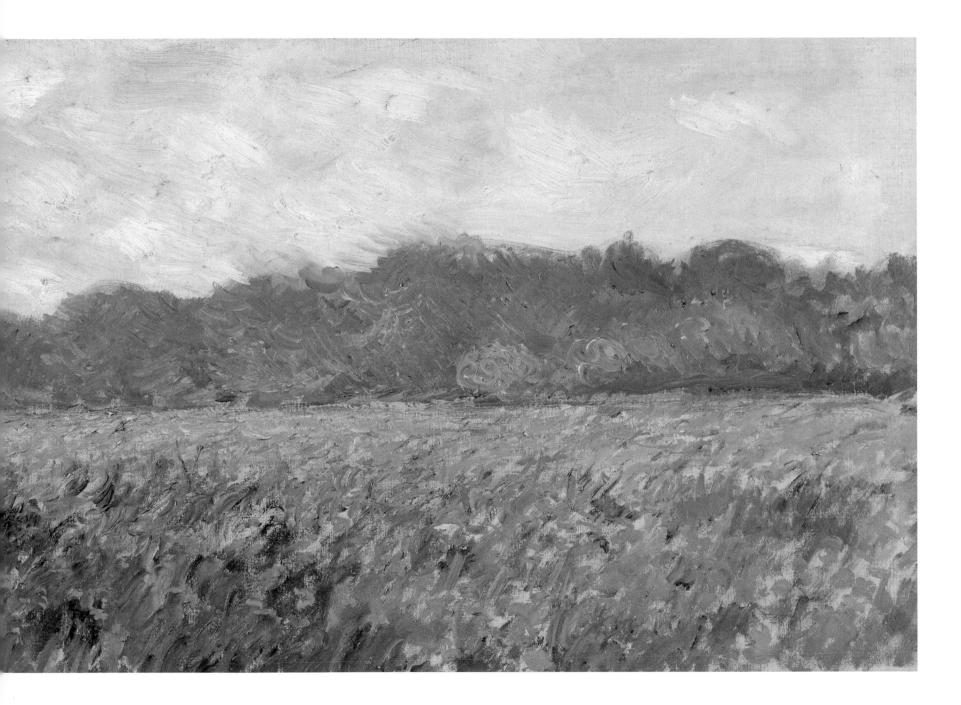

plate 1

CLAUDE MONET, **CHAMPS D'IRIS JAUNES À GIVERNY** (FIELD OF YELLOW IRISES AT GIVERNY), 1887

Oil on canvas; 17¾ x 39⅜ inches

Musée Marmottan Monet, Paris, France: Michel Monet Bequest, 1966

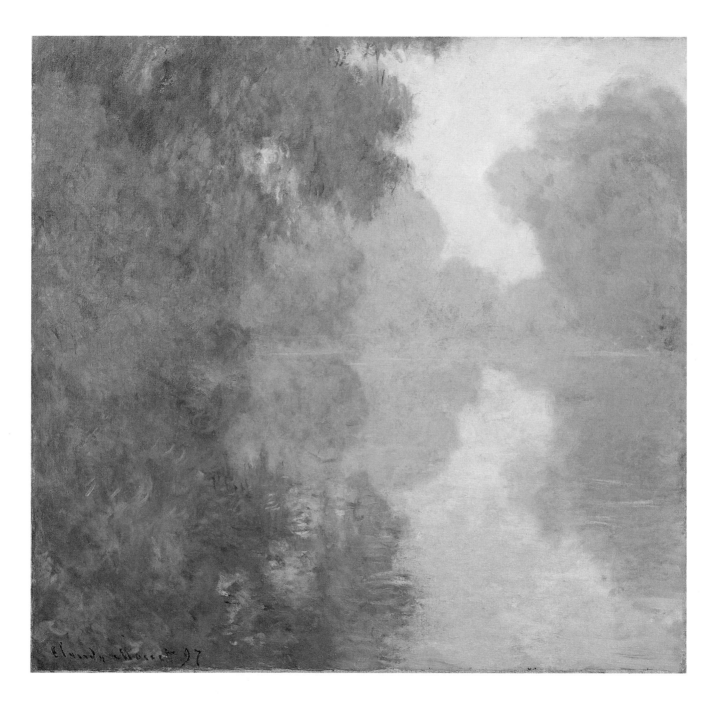

plate 2

CLAUDE MONET, **THE SEINE NEAR GIVERNY, MORNING MISTS**, 1897

Oil on canvas; 35 x 36 inches

North Carolina Museum of Art, Raleigh, North Carolina: Purchased with funds from the Sarah Graham Kenan Foundation

and the North Carolina State Art Society (Robert F. Pfifer Bequest). G. 75.24.1

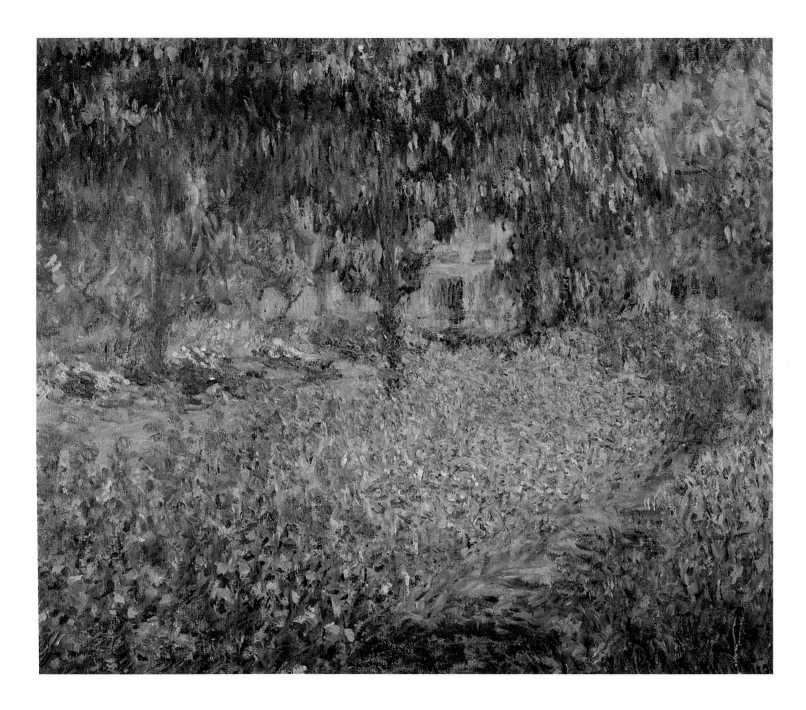

plate 3

CLAUDE MONET, **THE ARTIST'S GARDEN AT GIVERNY**, 1900

Oil on canvas; 31⅞ x 36¼ inches

Paris, Musée d'Orsay, reçu en paiement des droits de succession, 1982

26

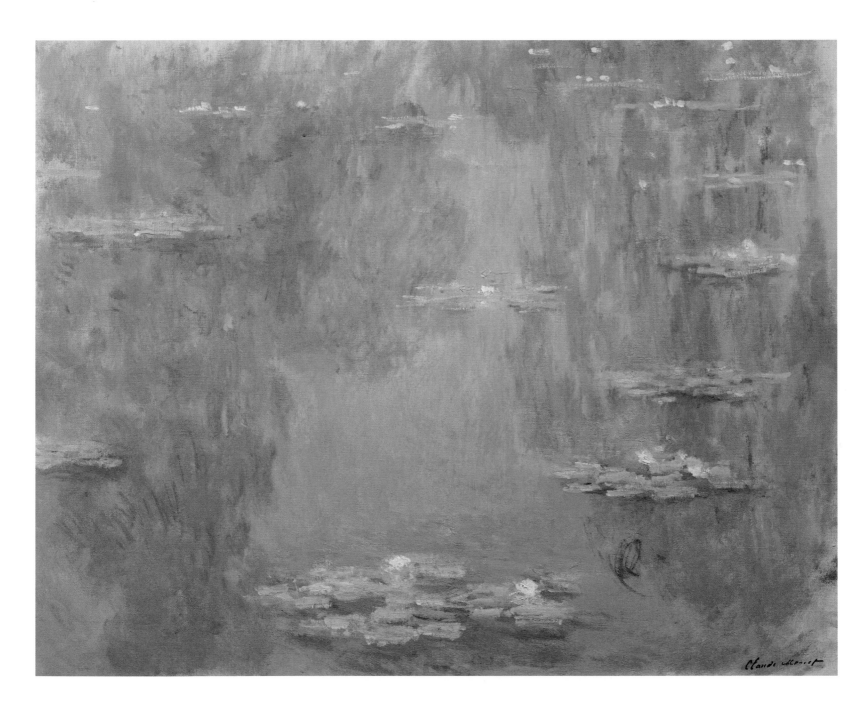

plate 4

CLAUDE MONET, **NYMPHÉAS** (WATER LILIES), 1903
Oil on canvas; 35 x 39½ inches
Musée Marmottan Monet, Paris, France: Michel Monet Bequest, 1966

28

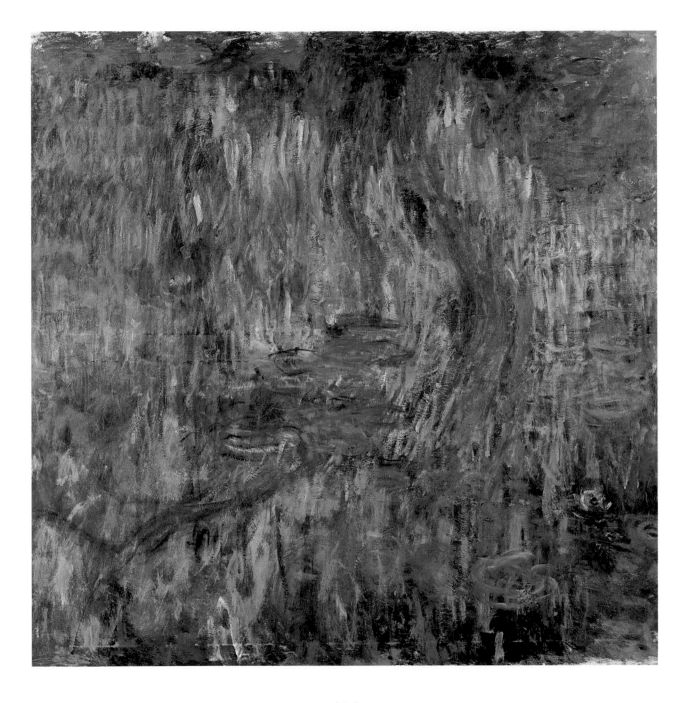

plate 5

CLAUDE MONET, **NYMPHÉAS, REFLETS DE SAULE** (WATER LILIES, WILLOW TREE REFLECTIONS), circa 1916

Oil on canvas; 78¾ x 70⅞ inches

Musée Marmottan Monet, Paris, France: Michel Monet Bequest, 1966

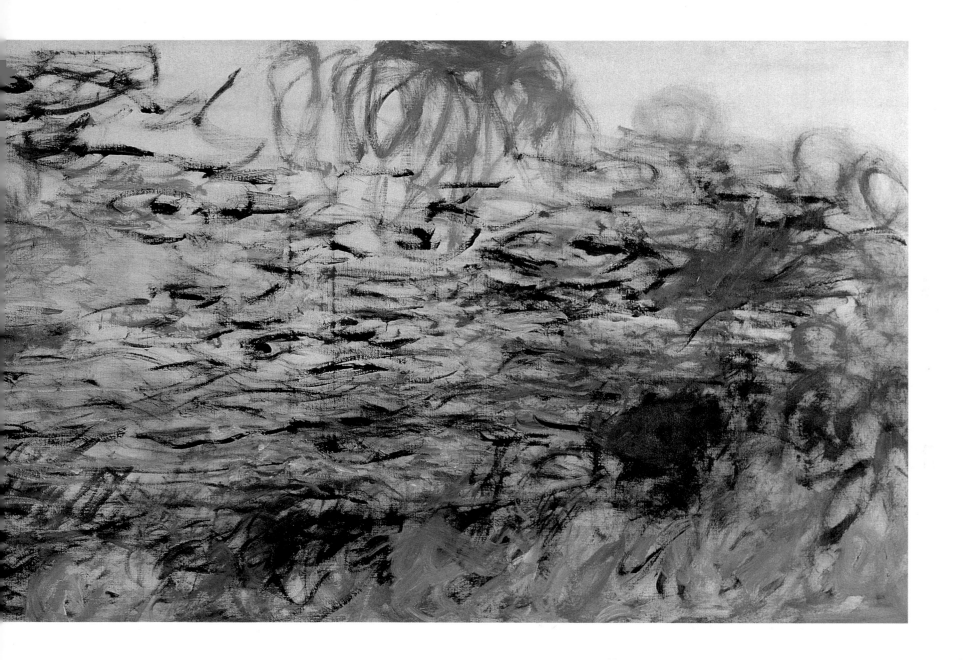

plate 6

CLAUDE MONET, **NYMPHÉAS** (WATER LILIES), circa 1917

Oil on canvas; 39⅜ x 118⅛ inches

Musée Marmottan Monet, Paris, France: Michel Monet Bequest, 1966

32

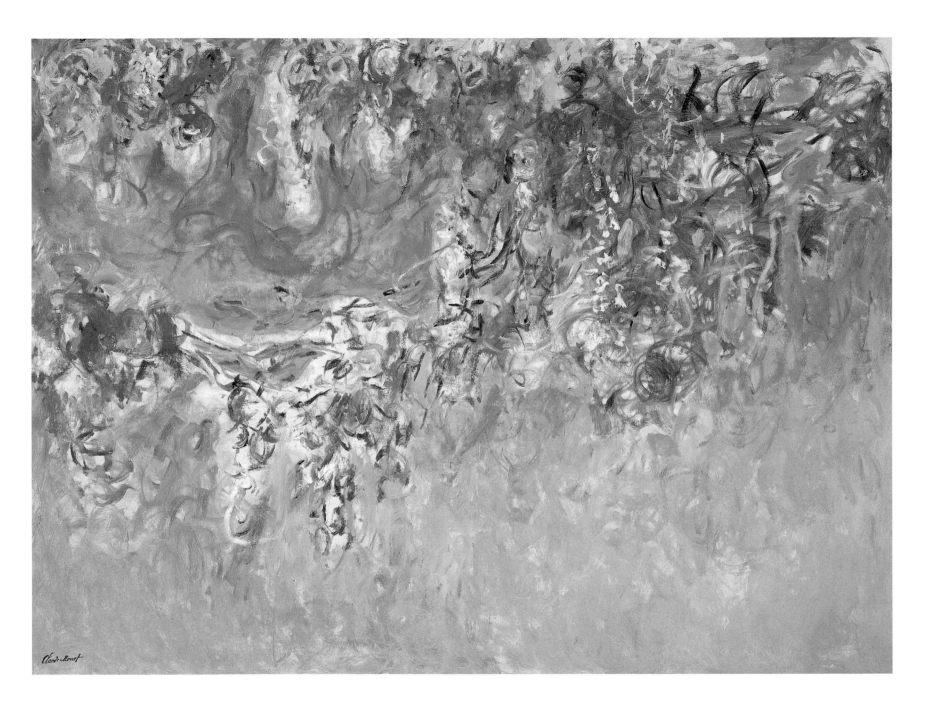

plate 7

CLAUDE MONET, **WISTERIA**, circa 1919–20

Oil on canvas; 59⅛ x 78¾ inches

Allen Memorial Art Museum, Oberlin College, Ohio; R.T. Miller, Jr., Fund, 1960

34

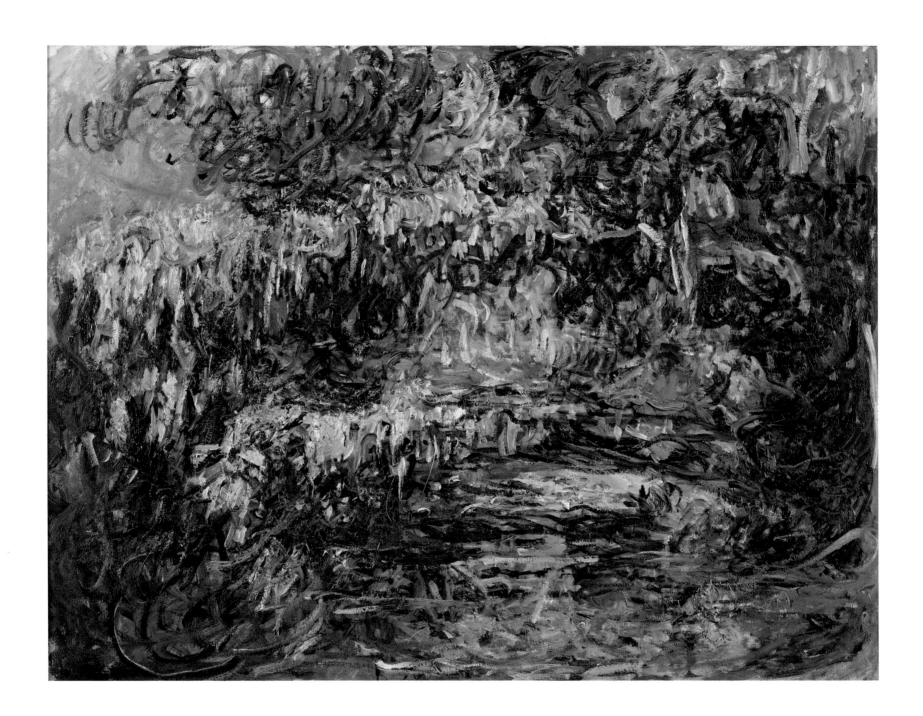

plate 8

CLAUDE MONET, **LE PONT JAPONAIS** (THE JAPANESE BRIDGE), circa 1918
Oil on canvas, 35 x 45⅝ inches
Musée Marmottan Monet, Paris, France: Michel Monet Bequest, 1966

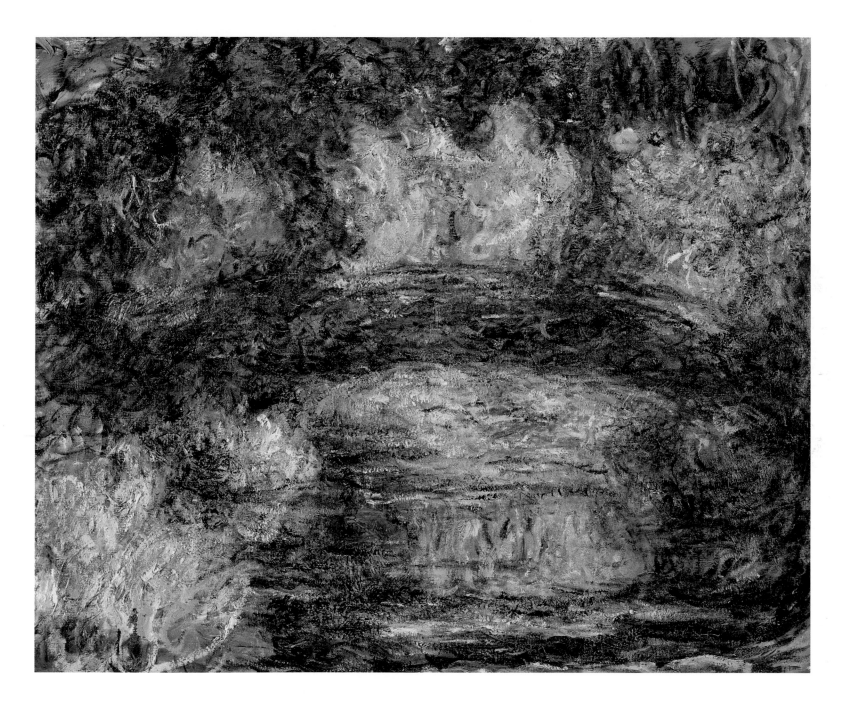

plate 9

CLAUDE MONET, **LE PONT JAPONAIS** (THE JAPANESE BRIDGE), circa 1918

Oil on canvas; 29⅛ x 36¼ inches

Musée Marmottan Monet, Paris, France: Michel Monet Bequest, 1966

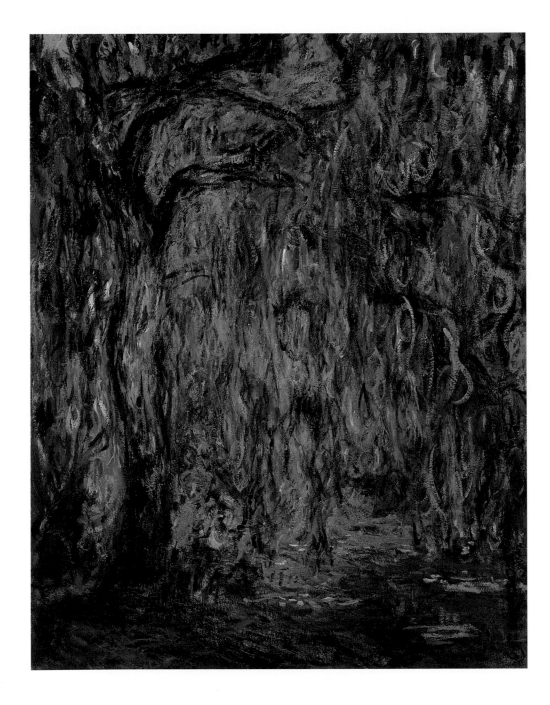

plate 10

CLAUDE MONET, **WEEPING WILLOW**, 1918
Oil on canvas; 51⅝ x 43⁷⁄₁₆ inches
Columbus Museum of Art, Columbus, Ohio, Gift of Howard D. and Babette L. Sirak, the Donors to
the Campaign for Enduring Excellence, and the Derby Fund. 1991.001.041

38

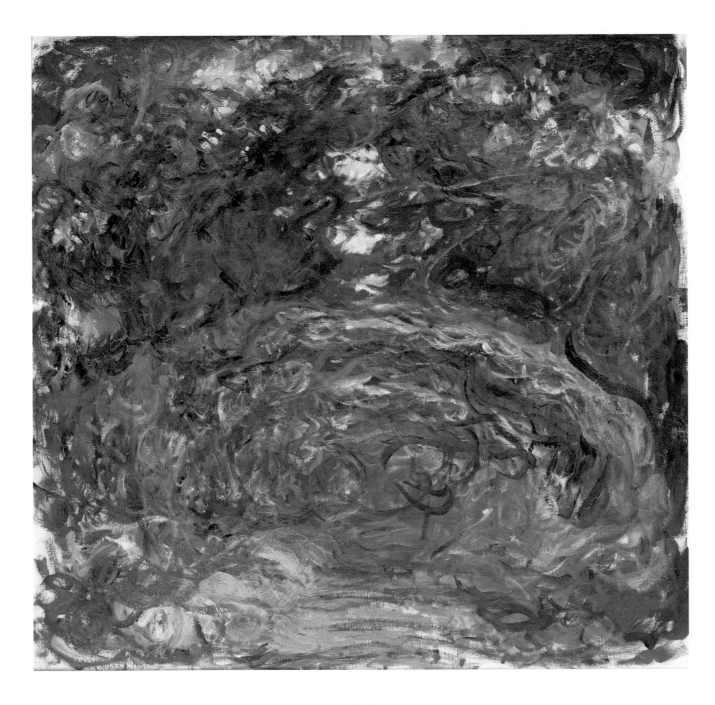

plate 11

CLAUDE MONET, **L'ALLÉE DES ROSIERS** (THE PATH UNDER THE ROSE ARCHES), circa 1920

Oil on canvas; 35⅜ x 36¼ inches

Musée Marmottan Monet, Paris, France: Michel Monet Bequest, 1966

40

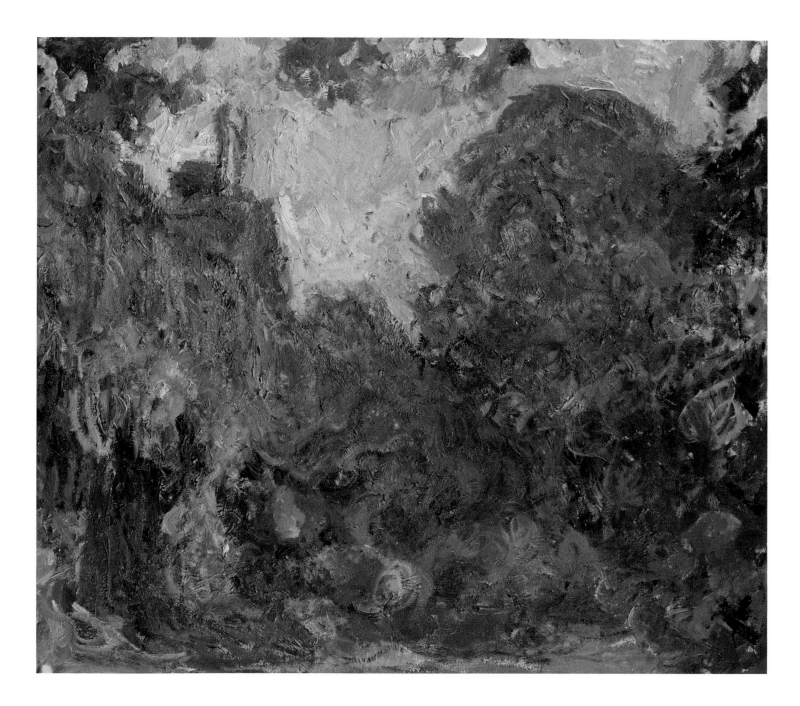

plate 12

CLAUDE MONET, **LA MAISON VUE DU JARDIN AUX ROSES** (THE HOUSE VIEWED FROM THE ROSE GARDEN), circa 1922

Oil on canvas; 31⅞ x 36¼ inches

Musée Marmottan Monet, Paris, France: Michel Monet Bequest, 1966

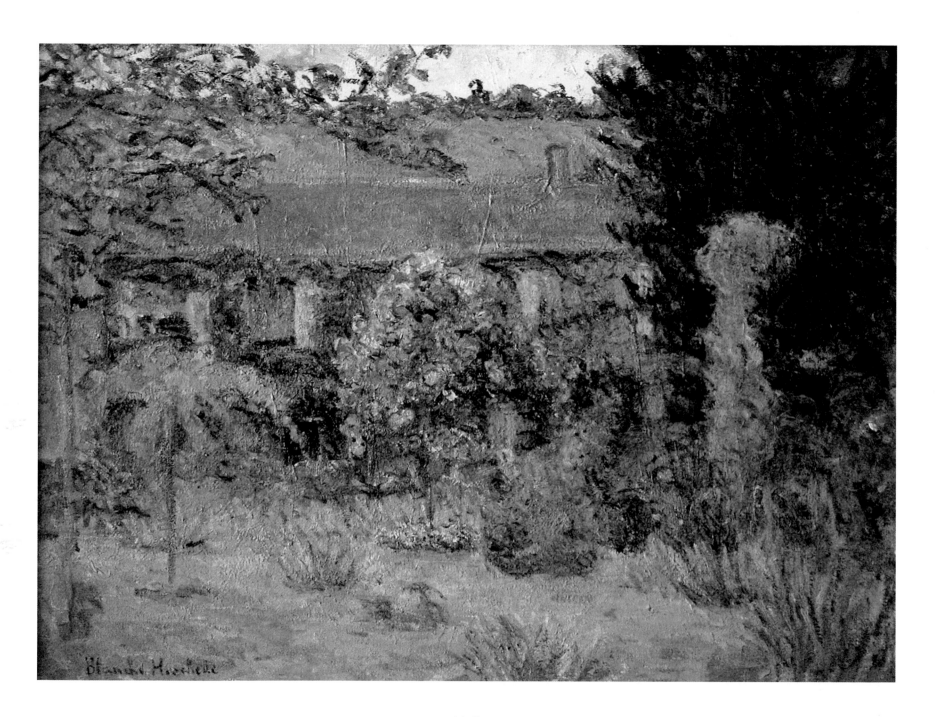

plate 13

BLANCHE HOSCHEDÉ MONET, **HOUSE OF CLAUDE MONET**, circa 1926–28

Oil on canvas; 23¾ x 32⅛ inches

Private Collection

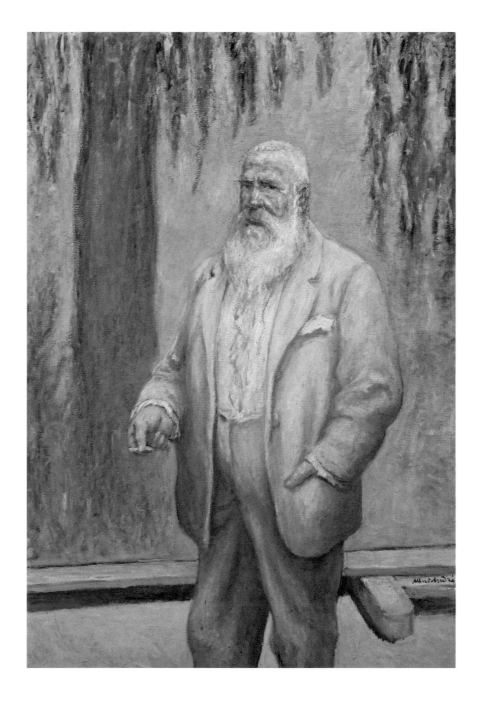

plate 14

ALBERT ANDRÉ, **PORTRAIT OF CLAUDE MONET**, 1922

Oil on canvas; 52¼ x 36½ inches

Frederic Bouin, New York, New York

Charles Stuckey

*Dedicated to memory of Jean-Marie Toulgouat,
grandson of Theodore Earl Butler*

# American Courtships
## WITH *Giverny*

FEATURING A SOUVENIR-MINDED COUPLE ON THE ARCHED WOODEN BRIDGE IN Monet's water garden, Ian Falconer's June 5, 2000, cover illustration for *The New Yorker* (fig. 6) spoofs the surprising extent to which the Impressionist's home outside of Paris has become a mecca for culture tourists. Opened to the public in 1980 under the auspices of the prestigious Académie des Beaux-Arts, the Monet museum at Giverny, with its careful replication of the artist's gardens, attracts some half a million visitors every year, despite the fact that there is not a single painting by Monet at his Giverny home today. Instead, what brings so many Monet enthusiasts to Giverny is the highly publicized place itself, an opulent horticultural sanctuary nestled among small farms and cottages.

At the time of his death in 1926 interest in Monet was rather restrained as Impressionist art was already considered rather old-fashioned. Monet's extraordinary cycle of *Nymphéas* murals, portraying his water lily pond at Giverny, attracted relatively few visitors when it was installed in Paris at the Orangerie in the spring of 1927.[1] Instead, what most caught the public's imagination at the time was Lindbergh's

opposite (detail)
LILLA CABOT PERRY, **A STREAM BENEATH POPLARS**, circa 1890–1900
See page 85

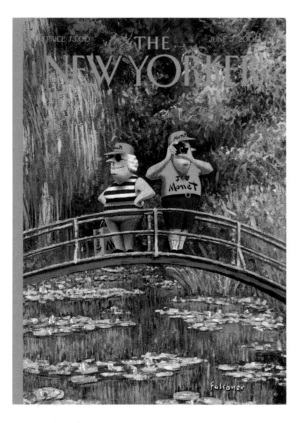

48

unprecedented transatlantic flight to Paris. For the playwright, Sacha Guitry, however, no one in France was more modern than Monet. Commissioned to celebrate the opening of the Théatre Pigalle in Paris on October 7, 1929, Guitry staged *Histoires de France,* consisting of fourteen brief scenes in chronological progression from ancient times to the present, each paradigmatic of the era in which it occurred (fig. 7). Opting to ignore aviators, film-makers, or other obvious celebrities of the modern age, Guitry featured two old men in the climatic scene symbolic of modern-day France—Monet and his best friend, Georges Clemenceau, twice prime minister of France (fig. 8). Their meeting takes place not in Paris, but in Monet's private garden in the little village of Giverny. Monet is at work painting his beloved water lilies when Clemenceau arrives to report the allied victory in World War I. To judge from today's widespread international recognition of Giverny as a shrine in the history of French art, Guitry got it right: what matters most in modern France is modern art with the metaphysical power to reveal timeless values.

But Giverny's heyday was over by 1929. The outbreak of war in 1914 quickly depleted Monet's household staff, including the half a dozen gardeners who maintained his small-scale private paradise. Like the painter's son, Michel Monet, and his stepson, Jean-Pierre Hoschedé, every able-bodied man was conscripted into the army. Moreover, as German forces pressed towards Paris, other Giverny families felt obliged to evacuate the village in harm's way. Not Monet. He stubbornly stood his precious ground in the company of his devoted daughter-in-law, Blanche Hoschedé Monet. The outbreak of war prevented her elder sister, Marthe Hoschedé Butler from returning to Giverny to be with them. The Butler family had already left Giverny in 1913 to join painter Theodore Butler, in New York to realize a mural project. They were visiting Butler's hometown of Columbus, Ohio, during the fateful summer of 1914 and remained in the United States until 1921.[2] (The loan of six paintings by Monet from the Galerie Durand-Ruel to the Columbus Gallery of Fine Arts in January 1916 was likely thanks to Butler family intervention.)

Butler, his children, and Blanche would preserve Monet's Giverny heritage into the 1930s, but the fastidious maintenance of Monet's preferences was relaxed after Blanche's death. While Blanche respected Monet's dissatisfaction with the late canvases, which he was unwilling to sell or exhibit, his son, Michel, realized the need to

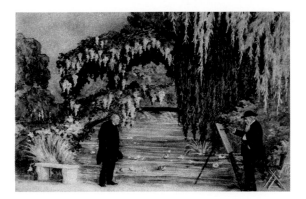

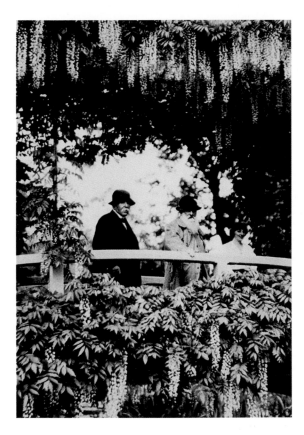

bring museum professionals and picture dealers to Giverny to look at these works, painted while the artist's eyesight deteriorated from cataracts.[3] The extremely broad brushwork characteristic of these late paintings, more expressionistic than subtle, came as a revelation in the late 1940s and early 1950s when abstract painters worldwide advocated unrestrained freedom of execution. By 1960, when the Museum of Modern Art in New York devoted an exhibition to Monet, his late works were at last widely appreciated for the profundity and modernity that had been immediately obvious to Clemenceau and Guitry.

The revived interest in works painted by Monet at Giverny prompted concern about the gardens so wondrously depicted in them. Thanks to the passionate advocacy of the young American scholar, Robert Gordon, working with Butler's grandson, Jean-Marie Toulgouat and his wife, Claire Joyes, the Académie des Beaux-Arts (to whom Michel willed the remnants of Monet's estate) undertook a long and costly restoration in strict accord with Monet's complex designs before opening the gardens to the public until 1980.[4] Joyes's 1975 influential monograph, *Monet at Giverny*, with its intriguing account of the village's robust art colony and with scores of unpublished Monet family photographs, focused serious attention on the history of the little village where, during and after World War I, Clemenceau liked to commune with Monet.[5] While there is hardly space here to provide anything like a complete historical account of the place, I will attempt to summarize events from the beginning years of Monet's Giverny, when a young painter from Columbus, Ohio, joined Impressionism's first family.

Monet was forty-two years old when in April 1883 he took up residence in secluded Giverny, a farming village with slightly less than 300 inhabitants situated some forty miles northwest of Paris on the right bank of the Seine River (fig. 9). The artist had begun looking at properties the previous March, in the much larger town of Vernon just across the Seine. Served by the Paris-Le Havre railroad, Vernon offered convenient access to Paris with its internationally acclaimed galleries of contemporary art essential to Monet's career as a struggling painter. Affordability, however, was at least as much of an issue for Monet as convenience. In 1883, the widowed painter needed a very large house to accommodate a ten-person household: his own two sons (aged fifteen and five); his thirty-nine-year-old partner, Alice Hoschedé; and her six children (aged nineteen, seventeen, fifteen,

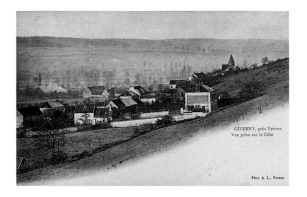

fig. 9
A. LAVERGNE (French, dates unknown)
**GIVERNY, PRÈS VERNON—VUE PRISE
SUR LA CÔTE** (View of Giverny)
Undated

Vintage postcard
Courtesy of Musée d'Art Américain Giverny/
Terra Foundation for American Art

thirteen, nine, and five). It is not known how much, if any, financial support was provided by Ernest Hoschedé,[6] who, before declaring bankruptcy in 1877, had been Monet's most important patron. Further complicating the situation, the awkward fact in 1883 was that Monet and Alice Hoschedé were living in adultery. Though well-suited to Monet's private life, the seclusion of Giverny was, however, hardly ideal for Alice Hoschedé's three teenage daughters, who had grown up expecting to become cosmopolitan debutantes.

For his strictly modest income Monet relied on the Paris dealer, Paul Durand-Ruel. The opportunity to move to Giverny was largely predicated on the commercial success of Monet's first solo exhibition with the Galerie Durand-Ruel in March 1883 and on the dealer's consequent willingness to advance funds. (It was in conjunction with this same exhibition that Monet's art was first mentioned in Clemenceau's radical newspaper, *La Justice*.)

Relatively little information survives about the house and grounds in Giverny as they were at the time the Hoschedés and Monets moved in; there are no photographs until 1887 or 1888 at the earliest and surprisingly few paintings. According to the bill of sale drawn up when Monet purchased

the property in 1890, the main house had four rooms on the ground floor and the same number upstairs, an attic with usable space and a cellar. On the west end was a barn and on the east end was a woodshed, a little hangar, and the outhouse. To the west of the main house was a smaller building with its own kitchen, storage room, and stable. Torn down around 1899 to make way for Monet's second studio, the little farm building (presumably a dormitory for the older boys when they were home from boarding school in Vernon) is visible in the background of several snapshots showing the family gathered under an arbor of lime trees. (It seems important to stress that Monet's arrival in Giverny in 1883 preceded the advent of widespread amateur photography by only a few years. Thanks to scores of informal photographs, Monet's Giverny years are well-documented in a medium other than simply written documents. A small, walled-in orchard with a rough grass groundcover, the property as a whole extends between the two east-west roads running through the village. The main house backs along the northern high road (called rue Claude Monet since the painter's death), and its front doorway faces a pair of yews flanking a roughly fifty-yard-long walkway leading to a gate at the southern road (the

Chemin du Roy). Across the Chemin du Roy and running alongside it are the tracks for a train service from Gisors to Vernon and also the Ru River (a tributary of the Epte which flows into the Seine not far from here). It was the Ru's running water that made it possible for Monet to create his exotic water lily pond beginning in 1893.

When the Monets and Hoschedés arrived Giverny consisted primarily of family farms. A local wine was produced from hillside vineyards. Crops were planted both on the plateau in the northern part of the village and also on the flood plain extending from the Ru, south to the Epte, and west to the Seine. A priest came once a week to a little church dedicated to Sainte Radegonde, with an apse dating back to the eleventh century. (Monets and Hoschedés are buried in its little graveyard .) According to Jean-Pierre Hoschedé's recollections, most villagers baked their own bread and only ate meat on Sundays.[7] Giverny had a bird catcher, a blacksmith, and a miller with two mills. Tobacco and simple groceries were available at four little bars where locals played dominos and billiards. There were proper stores across the river in Vernon with its Saturday outdoor market, though the healthy walk to Vernon could be avoided by taking the train with service twice a day.

The Monet-Hoschedé family kept three boats tethered near the confluence of the western branch of the Epte and the Seine: a canoe, a small flat-bottomed boat referred to as a "Norwegian," and Monet's studio boat with its enclosed cabin. By August 1883 Monet had already begun painting river motifs around Giverny from his studio boat.

Monet seemingly felt obliged to leave Giverny at the end of 1883, to make it less awkward for Alice's estranged husband Ernest to visit his children. Together with Renoir, Monet explored the Mediterranean coast from Marseilles to Genoa, stopping to visit their mutual friend Paul Cézanne in l'Estaque. Enthralled by the dazzling landscape, Monet returned to the Mediterranean on his own in mid-January, leaving Alice with all the huge household's problems for what turned out to be a three-month long absence. What we enjoy today as Monet's Giverny began to take shape in his mind during this trip. One of his letters to Alice describes his visit to an elaborate garden: "unlike anything, altogether like a fairy-tale, all the world's plants grow there freely, seemingly uncultivated; it is a jumble of every variety of palm, orange and mandarin…."[8]

A premonition of America's growing importance, Auguste Bartholdi's gigantic Statue of Liberty towered over the rooftops of Paris in 1884

(prior to its presentation to the American Minister on July 4). The Monets and Hoschedés would all have marveled at it during their frequent trips to the city, taking the train from Vernon. By the year's end Monet proposed to Renoir and Pissarro (recently settled in Eragny, near Giverny) that they institute monthly dinners in Paris as a way to maintain art world contacts. This dinner group soon included the critic and controversial novelist, Octave Mirbeau, himself an avid gardener, whose many writings about Monet provide some of the best accounts of Giverny.

It was during the summer or fall of 1884 that Monet first decided to paint haystacks in the wide meadow extending beyond his property to the Ru, its banks lined with poplar trees. Monet's three 1884 versions of this scene, each depicting a different sort of daylight, initiated a pictorial adventure that culminated in 1890–91 when the artist realized his famous series of *Wheatstacks* and then *Poplars* paintings, in the process elevating such ordinary countryside features into hallmarks of Giverny (fig. 10). Sensing his older colleague's obsession with the subject, during an 1885 visit to Giverny the American John Singer Sargent portrayed Monet at work on a Haystacks painting in the company of a young woman in a white dress

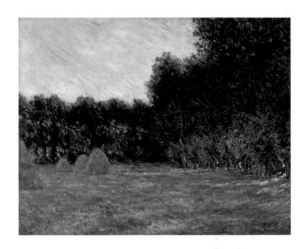

51

fig. 10
CLAUDE MONET (French, 1840–1926)
**MEADOW WITH HAYSTACKS NEAR GIVERNY**
1885

Oil on canvas; 29⅛ x 36¹³⁄₁₆ inches
Museum of Fine Arts, Boston, Massachusetts:
Bequest of Dr. Arthur Tracy Cabot. 42.541

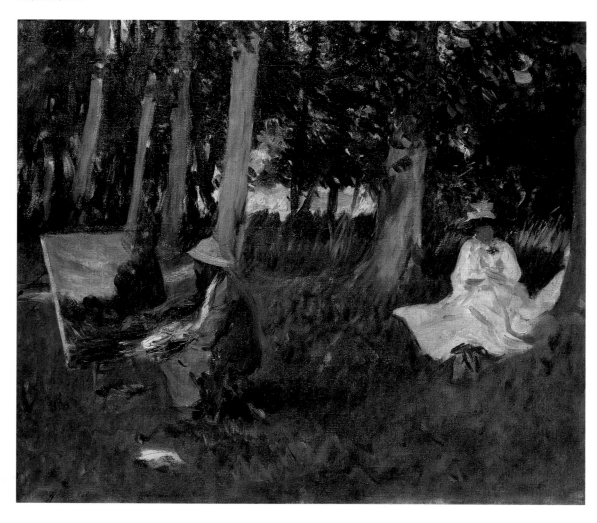

fig. 11
JOHN SINGER SARGENT
(American, 1856–1925)

**CLAUDE MONET PAINTING BY
THE EDGE OF A WOOD**
1885

Oil on canvas; 21¼ x 25½ inches
Tate, London, 2006

(probably seventeen-year-old Suzanne Hoschedé)
seated on the ground nearby and reading to him
(fig. 11). So attentively did Sargent record in minia-
ture the canvas underway on Monet's portable
easel that it can be identified with a work today
in the Museum of Fine Arts, Boston. Judging from
the dense complexity of Monet's brushwork,
this particular 1885 painting represented an impor-
tant departure from the famously stenographic
Impressionism characteristic of his canvases done
in single working sessions before 1880. In Giverny,
with all his supplies and family helpers nearby,
Monet began to devote multiple sessions to his
paintings, returning to the same particular motif
around the same time day after day, thus realizing
Impressionist paintings with unprecedented detail.[9]

By 1885 images of flowering fields dotted red
or yellow all over also became Giverny trademarks
(fig. 12). Two paintings of poppy fields were among
the first of Monet's Giverny works (along with
the same *Haystacks* recorded in Sargent's portrait)
ever to be exhibited, not in Paris, but in New York,
where Durand-Ruel had arranged a large
Impressionist survey exhibition to coincide with
the Franco-American hoopla marking the 1886
dedication of the Statue of Liberty. Throughout
the rest of the century paintings of Monet's village

would be continuously exhibited in American art centers, from Boston to Chicago, giving works by Monet, as well as by American artist pilgrims to Giverny, an ever more important place on the international Impressionist map. Responding to the 1886 New York exhibition, Helen Abbott Michael, a brilliant American critic writing under the name of "Celen Sabbrin," singled out Monet's *Poppy Field* paintings. Taking into account the pervasive emphasis on diagonal lines in Monet's paintings, Sabbrin proposed a "theory of triangulation" to understand them as abstract philosophical meditations about the underlying mathematical principles of nature.[10]

Such faraway enthusiasm for Giverny aside, in early 1886 Alice seriously considered separating from the painter for the sake of her daughters' happiness and success. Such domestic tensions may have prompted Monet to invite Suzanne to pose in the spring of 1886, quickly exhibiting a painting of her in the orchard at a group exhibition in Paris. As it turned out there was considerable interest in Monet's works at this particular exhibition staged by Durand-Ruel's rival, Georges Petit, and brisk sales put an end to the Monet-Hoschedé household's stressful financial situation. Meanwhile, thanks to Durand-Ruel's success with

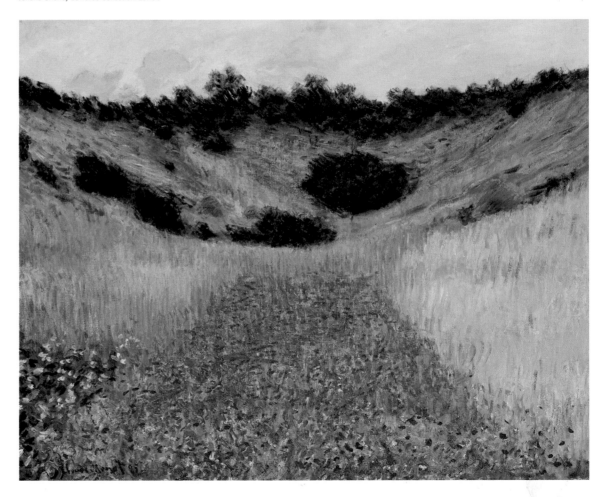

53

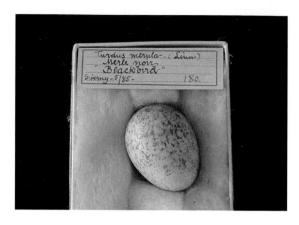

a quickly increasing number of American clients, Monet became a rich man within less than a decade of his arrival in Giverny.

Although the label for a blackbird egg in his collection records how Boston painter, Willard Metcalf passed through Giverny in May 1885 (fig. 13), it wasn't until 1886 that American artists took up summer residence.[11] Returning with Ohio painter, Theodore Wendel, Metcalf rented a hillside farmhouse. A painting by Metcalf, showing a "triangulated" poppy field with the Monet-Hoschedé home visible in the middle distance, is inscribed on the back: "La Maison de Claude Monet Giverny—Looking across from the end of my garden."[12] He may well have been working side by side with Monet, who himself painted more *Poppy Field* variations in 1886, and with twenty-year-old Blanche Hoschedé, who aspired to become a painter (figs. 14, 15). It is most unfortunate that very few of her earliest works can be located today, suggesting she may have discarded them from dissatisfaction just as Monet himself regularly destroyed his own sub-par works.

Angélina and Lucien Baudy, who ran a café on Giverny's Chemin du haut, arranged lodgings for still more Americans the following summer (figs. 16, 17). Besides Metcalf and Wendel the 1887 group included an obscure Ohio painter named Henry Fitch Taylor, peripatetic Theodore Robinson, his friend, Arthur Astor Carey, and the Canadian William Blair Bruce.[13] A second house was rented by New York artist, Louis Ritter, together with the Boston painter, John Leslie Breck, his brother Edward, and their widowed mother, Mrs. Ellen Rice. Accomplished amateur musicians, Mrs. Rice and Ritter provided evening concerts, ever afterwards a feature of the Giverny art colony. The three eldest Hoschedé daughters could only have been thrilled by the sudden enhancement of village life. As if they already took some fraternal pride in Giverny at this early date, Metcalf, Ritter, and Robinson all inscribed the name of the village on their paintings.

While Robinson's brushwork was hardly Impressionist by 1887, his earliest Giverny works are starkly "triangulated." As if symbolic of a modern phase of Impressionism, the sort of triangulation that Sabbrin had stressed as a feature of Monet's art is pervasive in the Americans' 1887 paintings of Giverny, from the shadowy views of the Epte by Metcalf (fig. 18) and Wendel (plate 29), to Bruce's 1887 bird's-eye-view of the eastern half of village. Bruce's painting may be the earliest of many panoramic views of Giverny painted by

Americans as souvenirs of their new colony.[14]

Exactly what Monet painted in 1887 is far from certain.[15] Quite a few of his Giverny works supposedly made in the 1880s are not inscribed with any date, and the dates on some others were added only after he agreed to sell them more than three decades later, then with debatable accuracy. To judge from Monet's letters, he attempted paintings of figures in the landscape throughout the summer of 1887, complaining in September of a need to destroy most of his recent works.[16] He was far more productive in Antibes where he arrived for a second long Mediterranean campaign in mid-January 1888.

During his absence several colonists wintered in Giverny, ice-skating on the Ru with their Monet-Hoschedé neighbors.[17] Several works confirm Breck's presence, including a portrait sketch of Suzanne inscribed as a gift to her mother on February 17, 1888.[18] Both Breck and Blanche Hoschedé were preparing works for the upcoming Paris Salon exhibition of contemporary art. Considering the limited romantic prospects in Giverny, the sisters may have competed with one another. Referring to nearly twenty-four-year-old Marthe Hoschedé, Monet wrote home on February 29: "To marry her, do you really have

fig. 18
WILLARD METCALF (American, 1858–1925)
**THE RIVER EPTE, GIVERNY**
1887

Oil on canvas; 12 ¼ x 15 ⅞ inches
Terra Foundation for American Art, Chicago, USA:
Daniel J. Terra Collection, 1989.6

fig. 19
JOHN LESLIE BRECK (American, 1860–99)
**POPPIES**
1890

Oil on canvas; 20⅛ x 26⅜ inches
Location unknown

56

some hope on the side of those Americans?"[19]

On trips into Paris Breck recruited new clients for the Baudys, who had decided to establish a country hotel equipped with studios for artists. Showing the Baudys' properties, Breck's "triangulated" snow scene, painted in February 1889 (plate 18), may be related to one of the two paintings that he exhibited at the Paris Salon.[20] Breck himself moved into the new hotel on April 4 and remained for nearly twenty months.[21] A snapshot shows him in what seems to be one of the new Baudy studios finishing a large painting of a field of yellow irises (plate 17) likely begun not long after he registered.[22] Breck made a gift to Robinson of a smaller version of the same iris subject treated as a close-up.[23] (While the idea of focusing intensely on a small fragment of living nature had many advocates outside of Giverny in the 1880s and 1890s, from Sargent to Vincent van Gogh, no painter is more closely associated with such close-up landscapes than Monet, who devoted nearly all his efforts after 1898 to what amount to hybrid landscape/still-life images of the water lilies cultivated in his garden.) Attached to a French model known only as Marie (who appears in many of his paintings), Robinson evidently sought more private accommodations than the hotel might

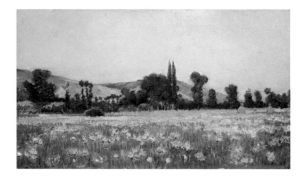

fig. 20
THEODORE WENDEL (American, 1859–1932)
**FLOWERING FIELDS**
1889

Oil on canvas; 12½ x 21⅝ inches
Terra Foundation for American Art, Chicago, USA: Daniel
J. Terra Collection, 1988.11

offer, but several summer-long guests registered at the Hotel Baudy in May just before Monet returned from Antibes: the English painter, Dawson Dawson-Watson, Philip Leslie Hale from Boston, and Butler. While Butler seemingly did not preserve his first works done in Giverny, one of Hale's earliest paintings, inscribed "Giverny" shows the field of yellow irises.[24]

Monet's Antibes paintings were purchased by Theo van Gogh (Vincent's brother), who put them on exhibition in June and July to considerable press acclaim. One journalist described a visit to the artist's home: "He does not have a studio as such. Living in the magnificent countryside of Giverny, not far from Vernon, he paints from morning to night.... He almost always has two or three canvases under way; he takes them with him and makes changes depending upon the weather conditions. This is his method. He never touches up his work in the studio."[25] As they proliferated in coming years, such newspapers accounts of Monet-land only spurred interest in the colony. When Giverny-ites visited Paris in 1888 to admire Monet's Antibes paintings on exhibition they also saw the Eiffel Tower being readied as the world's tallest structure for the Paris Exposition Universelle of 1889.

The expected crowds of international tourists concerned Monet, who began to plan an ambitious enterprise to coincide with the upcoming Exposition, which turned out to be a large, two-artist exhibition of his own paintings in tandem with the shockingly modern sculptures of his friend, Auguste Rodin. Monet devoted himself from May 1888 through the spring of 1889 to this retrospective, finally presenting nearly two dozen Giverny works, including hybrid landscape-figure paintings intended to surprise his audience as a new departure. Featuring his sons and the Hoschedé children as models, the realization of these works was stressful for Monet, who griped in June 1888 about the surfeit of American painters.[26] Monet may well have had proprietary feelings about particular Giverny sites with equal appeal for Breck (fig. 19) and Wendel (fig. 20). For example, with the 1889 exhibition in mind, Monet developed a closely related group of four paintings, standing exactly where Breck had stood in April to make his iris paintings. The dresses worn by Blanche and Germaine Hoschedé in these paintings appear to be the same ones worn by them when they posed for photographs outside the west end of their house with Suzanne, their mother, Monet and several American art colonists, including

Breck.[27] It is these snapshots and a group of late-1880s paintings by both Monet and the Americans that provide the only information about the appearance of Monet's earliest garden in Giverny.

Monet would develop his garden as a private work sanctuary in the early 1890s, but Breck often painted there in 1888 and 1889. It was the subject of as many as five of the fifty pictures listed without dates in the catalogue for a solo exhibition of Breck's works in Boston in 1890.[28] Known today only from a catalogue illustration, one of these featured the same six large decorative vases that appear in some of Monet's pre-Giverny garden paintings. The two garden paintings by Breck, today in the Musée Américain, were possibly included in his 1890 Boston exhibition. Painted from the exact same vantage point, conceivably on the same day, these interrelated works show the western section of the Monet-Hoschedé garden abloom in French tricoleur red, white and blue with peonies, poppies, and delphiniums (plate 16).

As for Monet, he evidently made paintings in his Giverny garden for the first time in 1888 although, unlike Breck, he did not exhibit them. Two related works show the central path bordered with nasturtium and planted with shrub roses: one

fig. 21
A. LAVERGNE (French, dates unknown)
**ENVIRONS DE VERNON—
PAYSAGE D'AUTOMNE À GIVERNY**
(Autumn Landscape near Giverny)
Undated

Vintage postcard
Courtesy of Musée d'Art Américain Giverny/
Terra Foundation for American Art

58

of these (inscribed "88") shows Germaine carrying cut flowers; the other (incorrectly inscribed "95") shows Suzanne wearing a red jacket and picking a single red flower. Dressed in this same outfit, Suzanne appears in several other works, all likely painted in 1888. None is more telling with respect to the exchanges with the Americans than a portrait of Blanche wearing a similar red jacket at work on a painting (now lost) that must have shown Monet at his easel. In the background Monet depicted a bearded painter (Breck) at work at another easel while Suzanne, wearing her red jacket, looks over his shoulder. Breck's (lost) picture would have portrayed Blanche and Monet as participants in this three-way paint-off on the lawn south of the main house.[29]

To judge from other surviving paintings, Breck and Monet as often worked side by side outside the garden in 1888. An undated Breck painting of the mill on a branch of the Epte at Limetz just south of Giverny corresponds closely to paintings of the same motif dated 1888 by Monet. Monet also painted in Blanche's company. Two works listed in Monet's 1889 retrospective catalogue as *Beneath the Poplars* probably correspond to paintings of Blanche Hoschedé standing at her easel near Suzanne, who sits on the ground reading. Aside

from his obvious effort to develop a style like Monet's, Robinson had seemingly little to do with the French artist's household. Rather than enlisting the Hoschedé women as models, Robinson worked with his mistress Marie and with a Giverny model named Josephine Trognon. Moreover he sometimes opted to paint across the Seine at the village of Arconville.[30]

By the end of 1888, Monet famously replaced his human models with two wheatstacks in the field next to his house (fig. 21), a motif that he would go on to paint in thirty variations during the next two years. He included two of these new *Wheatstacks* compositions in his large 1889 Paris exhibition, and wheatstack fever soon infected every painter who came to Giverny (figs. 22, 23).

At the 1889 Exposition Universelle in Paris Monet evidently met the horticulturist, Joseph Bory Latour-Marliac, who had on display a case of hybrid water lilies developed from reddish flowers he had imported from his recently deceased Boston counterpart, Charles Hovey. Three Boston girls arrived in Giverny in April, the daughters of the literary scholar, Thomas Perry (Henry James's friend and John La Farge's brother-in-law), and his painter wife, Lilla Cabot Perry. Presumably recruited by their fellow Bostonian Breck, the

Perrys joined their children at the end of June and remained through October. According to an August 2 Thomas Perry letter:

> There is [a camera] here and I mean to have some photos taken of the humble house where we dwell and of its also humble inhabitants. We are in a little peasant's house less than 200 steps from the hotel were we take our meals, yet far enough away to lose the sound of revelers and their clatter of plates and dishes. This is a very pretty spot ab[ou]t 40 miles from Paris, 50 by rail and is full of artists of greater and less degree. Two or three are rather competent; the rest are but beginners but they all keep up entertaining conversation. The stream of American humor flows on unceasingly and in the intervals of or after painting the tennis racquet is bro't forth and the game is played.[31]

The camera may have belonged to the Baudys or to Robinson, who took a room at the hotel in May. This same year Robinson used a photograph as the basis for a pensive figure painting of twelve-year-old Margaret Perry posed with her violin beside a garden wall.[32]

Breck's mother checked into the Hotel Baudy

fig. 22
THEODORE EARL BUTLER (American, 1860-1936)
**GRAINSTACKS, GIVERNY**
circa 1897

Oil on canvas; 21¼ x 28¾ inches
Collection of The Dixon Gallery and Gardens,
Memphis, Tennessee: Museum Purchase by the Dixon Life
Members Society. 1991.4

fig. 23
JOHN LESLIE BRECK (American, 1860-99)
**STUDIES OF AN AUTUMN DAY**
1891

Oil on canvas; 12⅞ x 16¹/₁₆ inches
Terra Foundation for American Art, Chicago, USA

59

fig. 24
THEODORE ROBINSON (American, 1852–96)
**PORTRAIT OF MONET**
1888–90

Cyanotype; 9⅞ x 6⅝ inches
Terra Foundation for American Art, Chicago, USA:
Gift of Mr. Ira Spanierman. C1985.1.6

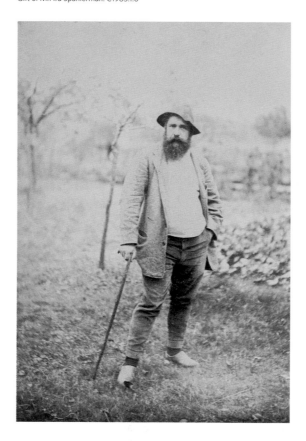

on September 16, 1889, and took her son with her when she returned to Boston at the end of October. Considering Alice Hoschedé's marital status, Mrs. Rice could hardly have approved of a liaison between her son and any of the Hoschedés. Suzanne appears despondent in a large portrait that Monet painted in October around the time of the Brecks' departure, as if aware that his absence would be lengthy.[33] According to Lilla Cabot Perry:

> Once and only once I saw [Monet] paint indoors. I had come to his studio and, finding him at work, was for going away at once, but he insisted on my coming in and sitting on the studio sofa while he went on painting. He had posed [Suzanne Hoschedé], a beautiful young girl in her teens, in a lilac muslin dress, sitting at a small table on which she rested one of her elbows. In a vase in front of her was one life size sunflower, and she was painted full length, but not quite life size as she was a little behind the sunflower. I was struck by the fact that this indoor picture was so much lower in key, so much darker than his out-door figures.[34]

It was likely during the summer of 1890 that Robinson photographed Monet as the basis for a portrait, eventually realized as a drawing but never in oils[35] (fig. 24). Responding to recent works made at the Bois de Boulogne by his Impressionist colleague, Berthe Morisot, Monet was struggling to make paintings of the Hoschedé sisters posed in a skiff on the Epte when Morisot and the poet, Stéphane Mallarmé, visited Giverny on July 13. Ten days later Clemenceau found Monet at work on a new set of his hallmark Poppy Field variations. "It was the beginning of a revolution, a new way of seeing, of feeling, of expressing." Clemenceau later recalled. "That poppy field, bordered by its three elms, marked an era in perception as well as in the expression of things."[36] Mirbeau wrote to Geffroy during July that Monet was gardening furiously.[37] Monet's most ambitious gardening dreams were already underway when he arranged to buy the Giverny house in November 1890—what amounted to a birthday present for himself as he turned fifty.

Unrealistically energetic, Monet had planned a sojourn in Rouen for February 1891 to paint the cathedral, but as he wrote to Geffroy on March 6, "I am up to my neck with workers, in the midst of all kinds of plantings and furniture rearrangements…."[38] He made no mention of Ernest Hoschedé, who had died at age fifty-three in Paris

60

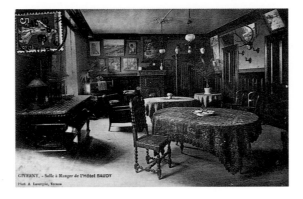

fig. 25
A. LAVERGNE (French, dates unknown)
**GIVERNY—SALLE À MANGER DE
L'HÔTEL BAUDY**
(Dining Room, Hotel Baudy, Giverny)
Undated

Vintage postcard
Courtesy of Musée d'Art Américain Giverny/
Terra Foundation for American Art

on March 18. At the request of Hoschedé's children, he was buried in the churchyard at Giverny. Also in March, as if the Giverny garden deserved consideration as a work of art in its own right, Mirbeau published an elaborate description of the painter's three distinct seasonal plantings in the March 1891 issue of a new art magazine published by Durand-Ruel.[39] Illustrated with reproductions of one of Monet's recent figure paintings and one of his brand new Wheatstacks paintings, Mirbeau's article was timed to heighten expectations for the exhibition scheduled for May at the Galerie Durand-Ruel. This exhibition, which included a suite of fifteen variations on his favorite motif of Wheatstacks at Giverny, all sold before the opening or shortly thereafter, established Monet in the minds of many as France's most important modern artist.

According to a June 9, 1891, Robinson letter, "The master is well, much occupied in his garden where he is planting flowers and things from all parts of the world."[40] The same day a Monet letter mentioned how he was awaiting the visit of a Japanese gardener, most likely Hata, who worked in Paris for James McNeill Whistler's patron, Comte Robert de Montesquiou-Fezensac.[41] Monet must have consulted Whistler as he redecorated the rooms of his Giverny house, famously painting the dining room in two shades of yellow.

The Hotel Baudy was busier than ever in 1891 (fig. 25). Breck (now engaged to marry an American) returned to Giverny on July 9, joined later that month by his mother, his brother, and his brother's opera singer wife. The Perrys and Boston painter Thomas Buford Meteyard also returned in July, and Breck's friend, the painter John Carroll Beckwith arrived in August with his wife, Bertha, another accomplished singer. Thomas Perry's letters and Beckwith's diary provide many details about this extraordinary summer activities: tennis and baseball, whist, charades, magic shows, and lots of Wagnerian music. During the summer Monet painted nearly two-dozen Poplars variations, working from his studio boat and changing from one canvas to another as shifting light changed the image, after only seven minutes in one case, as he explained to Lilla Cabot Perry. Meanwhile, Robinson, Meteyard, and Breck all did hallmark Giverny Wheatstacks as if under Monet's spell. Breck went so far as to make fifteen variations of a single Wheatstack painting, each with different colors observed as light conditions changed from dawn to dusk on a single day. Presumably he had obtained Monet's support for his project to decorate a room with these works installed

sequentially to form a frieze or dado,[42] otherwise, would he not have risked ostracism in the colony as a plagiarist? An entry in Beckwith's diary refers to some sort of serious rift in the colony in early September.[43]

Butler arrived only in October having returned to Ohio to be with his sick father, who died on August 19. Almost immediately he, too, found a Wheatstack to paint. Prominent in the background of Butler's 1891 painting is Giverny's Romanesque church, its form all but dissolved in the afternoon light the way solid forms dissolve in Monet's acclaimed Wheatstacks paintings.[44] Butler supposedly had the idea to produce a Giverny art colony newspaper, handmade with contributions by all its members. Sadly no issue of the *Courrier Innocent* has ever been found. In any case, Breck was unable to contribute, since Monet asked him to leave in November, concerned about his unacceptable relations with one of the Hoschedé women.

The mysterious dismissal of Breck worked in favor of Butler, who had decided to spend the winter in Giverny. Inevitably ice-skating provided the opportunity to spend time with the Hoschedés, like himself in mourning. By March 1892 Butler and Suzanne had fallen in love, and the prospect of

fig. 26
THEODORE EARL BUTLER
(American, 1860–1936)
**UNTITLED (MONET'S DAUGHTER, SUZANNE, AND HER CHILDREN)**
Undated

Oil on canvas; 46 x 46 inches

fig. 27
THEODORE EARL BUTLER
(American, 1860–1936)
**THE ARTIST'S CHILDREN, JAMES AND LILI**
1896

Oil on canvas; 46 x 45½ inches
Terra Foundation for American Art, Chicago, USA:
Daniel J. Terra Collection. 1987.2

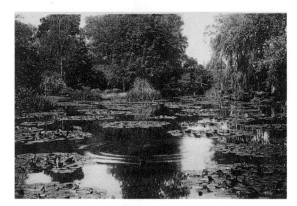

fig. 28
A. LAVERGNE (French, dates unknown)
**GIVERNY (EURE) PROPRIÉTÉ DU MAÎTRE CLAUDE MONET— ENSEMBLE DE LA PIÈCE D'EAU**
(Claude Monet's Water Garden, Giverny)
Undated

Vintage postcard
Courtesy of Musée d'Art Américain Giverny/ Terra Foundation for American Art

their marriage only increased Monet's already considerable stress. Monet had arranged another solo exhibition in February, this time an ensemble of his new Poplars paintings, while simultaneously working in Rouen on his next series, images of the cathedral facade miraculously dissolving in colored light. Returning to Giverny on weekends, Monet directed ongoing garden improvements while searching for a chief gardener to realize ever more ambitious plans, including the construction of a greenhouse this year on the west side of the property. Now, thanks to the young couple's impatience, Monet was obliged finally to convince the woman with whom he had already shared his life for a dozen years to marry him.

Having returned to America for an exhibition of his Giverny works in Boston, Robinson was back in time for the July weddings. According to his diary for 1892 the Monet-Hoschedé family, with Butler and their guests, would take walks in the garden after dinner with Chinese lanterns to light the way.[45] On July 9 Robinson took photographs of the Monet-Hoschedé clan minus Butler. One badly exposed photograph, also attributed to Robinson, shows the invited guests assembled for a meal in Monet's studio.[46] Curiously enough there is otherwise no visual record of either the

wedding of Monet and Alice Hoschedé on July 16, nor that of Butler and Suzanne Hoschedé four days later. In August Robinson made a much triangulated painting of the Butler wedding with the still beardless American painter and his French bride walking arm in arm along the Rue du Haut towards the church.

The newlyweds acquired a cottage known as the Maison Baptiste on the plot adjacent to the Monet compound.[47] Jimmy Butler was born exactly nine months after the wedding. Now Giverny had three distinct, albeit overlapping centers of activity: international art world figures (artists, dealers, collectors, critics) were received at the Monet house, while the Maison Baptiste became the primary headquarters for Americans spending the summer, some renting houses, other taking rooms at the hotel.

In February 1893 Monet bought a parcel of land just across the railroad tracks along the southern edge of his property and not without difficulty obtained permission to divert the Ru so that water would run through the pond that he excavated and spanned with the now-famous arched wooden bridge painted green. Early this same year Butler attempted a series of landscape paintings showing the local train that ran along

the Chemin du Roy, but figure painting became his forte in 1893 as he documented his own domestic life with Suzanne and Jimmy as primary models (fig. 26). He was able to exhibit one of his many paintings of Jimmy getting a bath in the summer of 1894 with the group of French artists who called themselves Nabis (or "prophets").[48] Butler may have grown his beard long around now as a sign of solidarity with this group, several of whom may have first met the Ohioan in the late 1880s when they all attended the same art school classes at the Académie Julian. Too often omitted from surveys of American art because he resided in France and too often omitted from surveys of French art because he was American, Butler created one of the most precious accounts of mid-1890s Giverny in many depictions of his household. After the birth of Lilly Butler in October 1894, Suzanne became very ill and could walk only with great difficulty. Her older sister Marthe helped mother the two little children (fig. 27), and she too appears in Butler's ongoing series of family paintings now set in a larger home built to accommodate the growing family.

Meanwhile throughout 1894 there was a constant stream of visitors to Giverny, invited to see the new water garden and the twenty-six

63

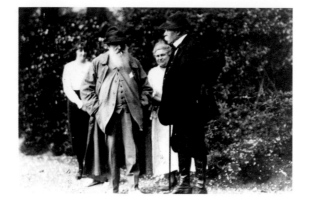

fig. 29
**LILI BUTLER RETURNED
TO GIVERNY**
Undated

Vintage photograph
Collection of Musée Clemenceau, Paris, France

Rouen Cathedral variations that Monet had finally completed to his satisfaction. Rather than exhibit them right away, Monet waited for dealers and collectors to make competing offers. Cézanne, who stayed at the Hotel Baudy for three weeks in November 1894, was greatly impressed with Monet's success: "[Monet] is a great lord.... If he likes a little field, he buys it.... so that no one comes to disturb him. That's what I need."[49] Monet invited his most influential art world friends to meet Cézanne on this occasion, helping to arrange for his old friend finally to have an exhibition of his art in Paris. Ambroise Vollard, the dealer who agreed to show Cézanne's work in 1895, would also host a one-artist exhibition of Butler's Giverny paintings at his gallery in 1897.

As Cézanne realized, Monet now increasingly used his garden as a private out-of-doors studio, painting the Japanese bridge for the first time in 1895 and painting his exotic water lilies by no later than 1897. By then Giverny as a place had taken its final form. Like everywhere else, Giverny was invaded with a rapid succession of modern devices—bicycles, then cars and electric lights, to name the most obvious. Suzanne's health never improved, no matter how many doctors and cures were tried. She died at age thirty in February 1899.

(By coincidence, Breck died unexpectedly in Boston the following month.)

There is no way to know whether Giverny would have continued to thrive as an artists colony up until the outbreak of World War I if Butler had opted to move back to Ohio with his children. He did return to America in September 1899, probably seeking the emotional support of his old friends. Marthe Hoschedé came along to help watch the children while Butler prepared for a one-artist exhibition at Durand-Ruel's New York branch. Whether they visited Columbus on this trip is not known. What mattered was that Butler decided to remain in Giverny as part of the Monet family (fig. 29). Returning to France in April 1900, he and Marthe married on All Saints Day, in remembrance of Suzanne. In the end, Columbus, Ohio, will always have an ongoing spousal relationship to Giverny, the place where Impressionism became most American and lasted longer than anywhere else.

NOTES
1. Charles F. Stuckey, "Blossoms and Blunders: Monet and the State, II," *Art in America* (September 1979): 121.

2. Richard H. Love, *Theodore Earl Butler, Emergence from Monet's Shadow* (Chicago: Haase-Mumm Publishing Company, Inc., 1985), 362, 378, and 398.

3. Christian Geelhaar, "Claude Monets Nymphéas in Basel: 1949 and 1986," in *Claude Monet: Nymphéas, Impression, Vision* (Basel: Kunstmuseum, 1986), 9–11; and Michael Leja, "The Monet Revival and New York School Abstraction," in *Monet in the 20th Century* (Boston: Museum of Fine Arts Boston, and London: Royal Academy of Arts, 1998), 98–108.

4. Anon, "The Monet Demesne: A Case for Restoration" and Robert Gordon, "The Lily Pond at Giverny: The Changing Inspiration of Monet," *Connoisseur* (November 1973): 153–165.

5. Claire L. Joyes, *Monet at Giverny* (London: Mathews Miller Dunbar, 1975). She expanded this text into *Claude Monet: Life at Giverny* (New York and Paris: Vendome Press, 1985).

6. Daniel Wildenstein, *Monet or the Triumph of Impressionism,* (Los Angeles: Taschen, and Cologne: Wildenstein Institute, 1996), 172 and 179. This is a slightly revised version of Wildenstein's definitive biography of the painter, published in French as *Claude Monet: Biographie et catalogue raisonné,* 4 vols. (Lausanne: Bibliothèque des Arts, 1974–1985).

7. Jean-Pierre Hoschedé, *Claude Monet, Ce Mal Connu* (Geneva: Pierre Cailler Éditeur, 1960), 1, 19–28.

8. Wildenstein, 1979, vol. II, 236 (letter 407).

9. Monet wrote to Durand-Ruel at the end of July 1885 (Wildenstein, 1979, vol. II, 261 (letter no. 578)): "I am working with determination, but more and more laboriously, that is I am becoming very exacting. I have two canvases on which I have been working for a month, but I swear that I would regret seeing certain of these canvases leave for Yankee country." The best discussion of Monet's new style is Robert L. Herbert, "Method and Meaning in Monet," *Art in America* (September 1979): 90–108. After visiting Monet Sargent returned to England where he immediately adopted Monet's method, devoting scores of brief twilight work sessions with two child models holding paper lanterns to *Carnation, Lily, Lily,*

*Rose*, greatly acclaimed at the Royal Academy exhibition in 1887 and purchased immediately by the Tate Gallery.

10. Celen Sabbrin, *Science and Philosophy in Art* (Philadelphia: Wm. F. Fell, 1886).

11. For other possible 1885 American visitors to Giverny, see Sona Johnston, *In Monet's Light: Theodore Robinson at Giverny* (Baltimore: The Baltimore Museum of Art, 2005), 51.

12. *Americans in Paris, 1860–1900* (London: National Gallery of Art, and New York: Metropolitan Museum of Art, 2006), 249 (no. 72). According to Johnston, op. cit., 86, this farmhouse was rented from the Ledoyen family of Angelina Baudy. One of Monet's Poppy Field paintings (W997) also shows his house in the middle ground.

13. For Bruce and Carey, see Love, op. cit., 55; and Johnston, op. cit., 54 and 150.

14. Robinson was especially fond of such panoramic views of Giverny, and the Monet-Hoschedé house is visible in the earliest of them from 1888. See Johnson, op. cit., 160–161 (nos. 45 and 46).

15. One of Monet's few securely dated 1887 works (W1125) is today in the collection of the Columbus Museum of Art, but it depicts not Giverny, but Bennecourt.

16. Wildenstein, 1979, vol. III, 223 (nos. 794–795) and 298 (no. 1424).

17. Ibid., 226 (no. 814).

18. It seems quite possible to me that the unfinished portrait of Monet wearing a beret, now in the Musée Marmottan, Paris, and attributed to Monet himself (W891a), may also be by Breck.

19. Wildenstein, 1979, vol. III, 231(letter 846).

20. Kathryn Corbin, "John Leslie Breck, American Impressionist," *Antiques* (November 1988): 1145. The winter scene is now in the collection of the Carnegie Museum of Art, Pittsburgh.

21. Now belonging to the Philadelphia Museum of Art, the guest register of the Hotel Baudy from 1887–1899 has been transcribed and published: Carol Lowrey, "Hotel Baudy Guest Register" in William H. Gerdts, *Monet's Giverny: An Impressionist Colony* (New York: Abbeville Press, 1993), 222–227.

22. Ibid., 1142. Depicting a woman seated on the ground, a small framed painting visible in the same snapshot suggests how Breck may have already enlisted members of the Hoschedé clan to model for him.

23. Now in the collection of the Terra Foundation for American Art. It seems possible to me that this work might be a fragment of the "lost" work visible on the easel in the snapshot of Breck at work mentioned above.

24. *Landscape with Figure*, 1888, Terra Foundation for American Art. For a color reproduction see Gerdts, op. cit., 168.

25. G[eorges] J[eanniot], "Claude Monet, La Cravache Parisienne," June 1888, 1–2. For a translation of this article, see Charles Stuckey, ed., *Monet: A Retrospective* (New York: Hugh Lauter Levin Associates, Inc., 1985), 129.

26. Wildenstein, 1979, vol. III, 298 (letter 1425).

27. One slightly overexposed version of this photograph with Breck seated at right was published by Hoschedé, op. cit., I, following 31. The best reproduction of the other version, with Breck standing at right, is to be found in Claire L. Joyes, *The Taste of Giverny: At Home with Monet and the Impressionists* (Paris: Flammarion, 2000), 68. Whenever this photograph is reproduced, the man sitting at the feet of the Hoschedé women is misidentified as Breck. For Robinson and photography, see Stephanie Mayer, *First Exposure,*

*The Sketchbooks and Photographs of Theodore Robinson* (Giverny: Musée d'Art Américain, 2000).

28. *Paintings by John Leslie Breck* (Boston: St. Botolph Club, 1890). Sixty works are listed (albeit without dates or dimensions) and three are reproduced.

29. In Wildenstein's catalogue these garden paintings are W1207, W1420, and W1330. Generally dated later, Hale's image of two empty chairs in a garden (Gerdts, op. cit., 47 for a reproduction) should perhaps also be a work from1888, considering the presence in the background of a young woman wearing a red jacket. If so, Hale made very rapid progress as an Impressionist this summer. Often incorrectly attributed to Sargent, an undated painting of Monet and Blanche at work on the studio boat ought quite possibly to be attributed to Breck. For a reproduction see Wildenstein, 1979, vol. III, 39.

30. Johnston, op. cit., 114 and 142 ff.

31. Letter fro Thomas S. Perry to Leonard Opdyke, August 2, 1889, in Thomas Sergeant Perry Papers, Colby College Library, Waterville, Maine. Also see Meredith Martindale, *Lilla Cabot Perry, An American Impressionist* (Washington, D.C.: The National

Museum of Women in the Arts, Washington, 1990.

32. Johnston, op. cit., 116–117.

33. The painting is Wildenstein no. 1261. For a letter in which Monet refers to this work in progress, see Wildenstein, 1991, vol. V, 194 (letter 2767).

34. Lilla Cabot Perry, "Reminiscences of Claude Monet from 1889 to 1909," *The American Magazine of Art* (March 1927): 123.

35. Dated 1890, the drawing was reproduced in Theodore Robinson, "Claude Monet," *Century Magazine* (September 1892): 697.

36 Georges Clemenceau, "Révolution des cathédrales," *La Justice*, May 20, 1895, 1. For a translation, see Stuckey, op. cit., 176–177.

37. Octave Mirbeau, *Correspondance avec Claude Monet*, eds. Pierre Michel and Jean-François Nivet (Du Lérot éditeur, Tusson, Charente, 1990), 98n4.

38. Wildenstein, 1991, vol. V, 196 (letter 2806).

39. Octave Mirbeau, "Claude Monet," *L'Art dans les Deux Mondes*, March 7, 1891, 183. For a translation, see Stuckey, op. cit., 157–159.

40. Theodore Robinson to

Thomas Sargeant Perry, June 9, 1891, Archives, Museum of Fine Arts, Boston.

41. Wildenstein, 1979, vol. III, 261 (letter 1111bis). For Hata and Whistler, see Edgar Munhall, *Whistler and Montesquiou: The Butterfly and the Bat* (New York: The Frick Collection, 1995), 38.

42. See Corbin, op. cit., 1146 for a snapshot showing these works installed in frieze fashion in Breck's studio. For color reproductions of all the remaining canvases from the Breck series, see *Lasting Impressions: American Painters in France, 1865–1915* (Giverny: Musée Américain, 1992), 154–160.

43. The diary is today among the James Carroll Beckwith papers at the Archives of American Art.

44. For a reproduction of Butler's painting, see Love, op. cit., plate 1 opp. 66.

45. The Monet-related diary entries are all transcribed in Johnston, op. cit., 189–195.

46. Johnston, op. cit., 140.

47. Love, op. cit., 115.

48. Ibid., 145, 147.

49. Joachim Gasquet, *Cézanne*, rev. ed. (Paris: Bernheim-Jeune, 1926), 149.

plate 15

KARL ANDERSON, **THE IDLERS, AUGUST**, 1909

Oil on canvas; 49¾ x 51⅝ inches

Brauer Museum of Art, Valparaiso University: Gift of Percy H. Sloan (53.01.109)

plate 16

JOHN LESLIE BRECK, **GARDEN AT GIVERNY**, between 1887–91

Oil on canvas; 18 x 21⅞ inches

Terra Foundation for American Art, Chicago, USA, 1999.18

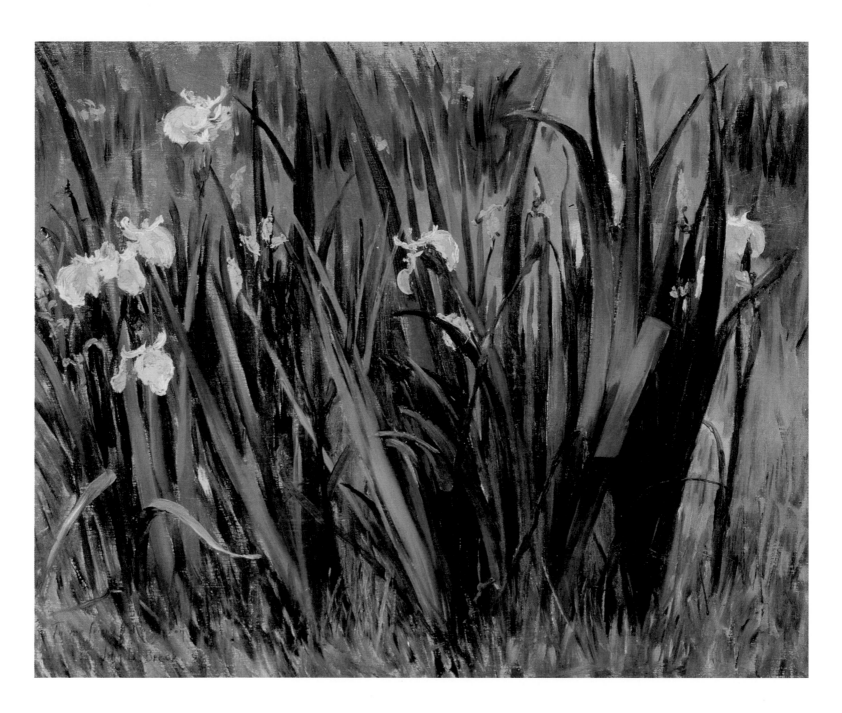

plate 17

JOHN LESLIE BRECK, **YELLOW FLEURS-DE-LIS**, 1888

Oil on canvas; 17 7/8 x 21 7/8 inches

Terra Foundation for American Art, Chicago, USA, 1989.2

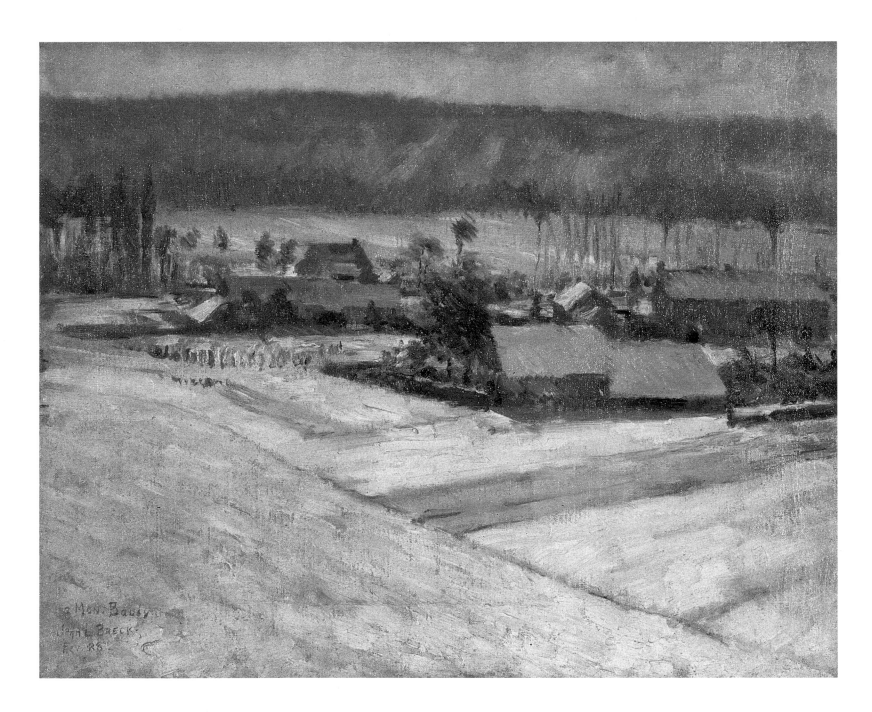

plate 18

JOHN LESLIE BRECK, **GIVERNY WINTER**, 1889
Oil on canvas; 14 x 18 inches
Carnegie Museum of Art, Pittsburgh, Pennsylvania: given anonymously in honor of the late Adolph W. Schmidt.  2000.51.1

plate 19

THEODORE BUTLER, **ENTRANCE TO THE GARDEN GATE**, 1898

Oil on canvas; 28 x 23 inches

Private Collection

plate 21

THEODORE BUTLER, **COTTAGE AT GIVERNY**, 1907
Oil on canvas; 23½ x 28½ inches
Private Collection

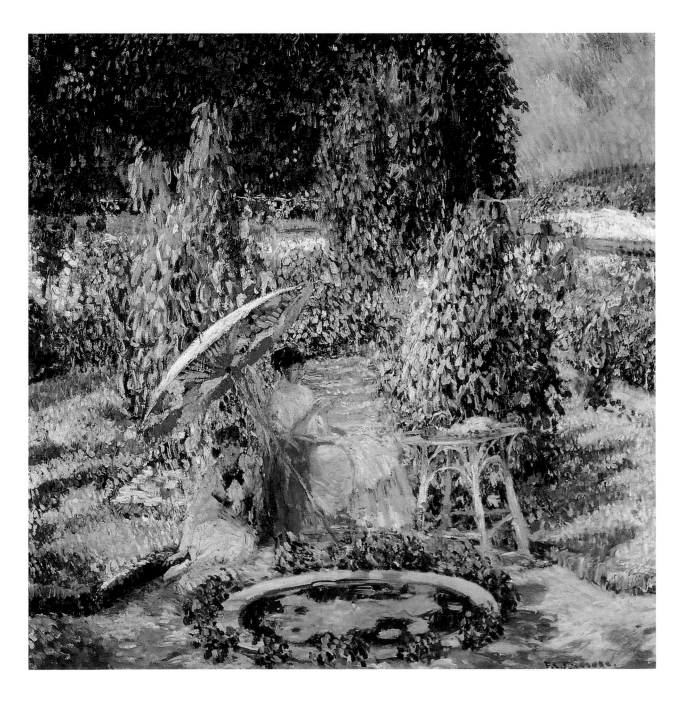

plate 22

FREDERICK FRIESEKE, **THE GARDEN UMBRELLA**, 1910

Oil on canvas; 32⁵⁄₁₆ x 32⁵⁄₁₆ inches

Telfair Museum of Art, Savannah, Georgia: Bequest of Elizabeth Millar (Mrs. Bernice Frost) Bullard. 1942.7

plate 23

WILLARD METCALF, **SPRING LANDSCAPE, GIVERNY**, 1887

Oil on canvas; 19½ x 25¾ inches

Collection of the Butler Institute of American Art, Youngstown, Ohio

plate 24

LILLA CABOT PERRY, **A STREAM BENEATH POPLARS**, circa 1890–1900

Oil on canvas; 25¾ x 32 inches

Hunter Museum of American Art, Chattanooga, Tennessee, Gift of Mr. and Mrs. Stuart P. Feld

86

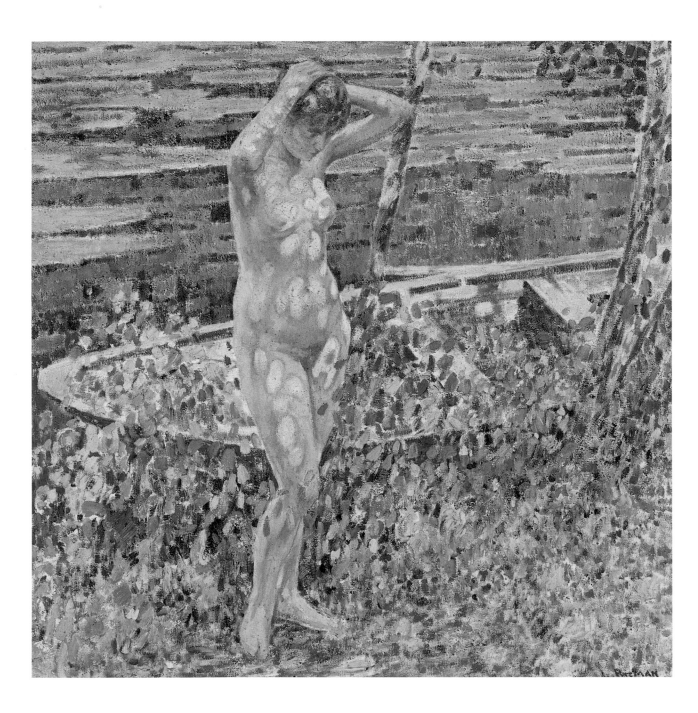

plate 25

LOUIS RITMAN, **NUDE, STUDY NO. 1**, 1915

Oil on canvas; 36½ x 36½ inches

Des Moines Art Center, Permanent Collections; Gift of Florence Carpenter, 1941.4

88

plate 26

THEODORE ROBINSON, **AFTERNOON SHADOWS**, 1891

Oil on canvas; 18¼ x 21⅞ inches

Museum of Art, Rhode Island School of Design, Providence, Rhode Island: Gift of Mrs. Gustav Radeke. 20.206

plate 27

THEODORE ROBINSON, **BY THE BROOK**, circa 1891

Oil on canvas; 18 x 23⅜ inches
Collection of the Montclair Art Museum, Montclair, New Jersey: Gift of William T. Evans. 15.39

plate 28

THEODORE ROBINSON, **LA DÉBÂCLE**, 1892

Oil on canvas; 18 x 22 inches

Scripps College, Claremont, California. Gift of the General and Mrs. Edward Clinton Young, 1946

plate 29

THEODORE WENDEL, **GIRL FISHING, GIVERNY**, circa 1887

Oil on canvas; 16¼ x 19½ inches

Mr. Whitney B. Wendel

James Yood

# *Making* MONET *Matter*

## GIVERNY AND MODERN ART

IN VINCENTE MINNELLI'S 1951 FILM *AN AMERICAN IN PARIS* (fig. 30), GENE KELLY, playing the spry but down-at-the-heels ex-GI Jerry Mulligan, waxes poetic about why he's struggling as a painter in France and not in his native New Jersey: "I'll tell you why—I'm a painter. And for a painter, the mecca of the world, for study, for inspiration, and for living is here on this star called Paris. Brother, if you can't paint in Paris you might as well give it up and marry the boss's daughter." Later in the film Kelly gets more specific about the lure of Paris, wistfully rising to its defense when another character notes that it can be a place both heartless and cruel: "Not this city, it's too real, too beautiful. I came to Paris to study and to paint it, like Utrillo did, Lautrec did, Rouault did. I loved what they created."

While his studies and romance in *An American in Paris* take place just after World War II, the mindset Kelly/Mulligan describes is of a slightly earlier vintage. That sense of cultural obeisance that Kelly alludes to, the unquestioned deferral by an American to Europe as the sole repository of all that is prestigious and worthwhile in art reflects a Eurocentric tradition deeply, practically causally, embedded in the

opposite (detail)
YEARDLEY LEONARD, **WAIT FOR ME**,
2004; See page 129

96

history and procedures of American culture. But if Kelly/Mulligan had looked around France in 1951 with a sharper eye, he might have noticed some significant changes in the air, changes that continue to characterize the United States/Europe intersection to the present day. What once had been the expected template for the development of an artistic career in America—that a young artist travel to Europe for an extended period of intense study, often for years, sometimes repeatedly doing so, immersing him- or herself in the Grand Manner before returning (if ever) to the United States— had begun to falter as a model for the professional American artist. Already by the late nineteenth and early twentieth centuries the Grand Manner and the traditions it implied had begun to give way to the pursuit of the Modern Manner, to contemporary artists, as exemplars for young American artists, the likes of Europeans such as Michelangelo and Poussin supplanted by more recent European artists such as Monet and Picasso. Europe by 1945, though chastened and exhausted by the Great Depression, the Holocaust, World War II, and the immediate rise of the brinksmanship of the Cold War, began to cede its previously unquestioned cultural authority and dominance to America, specifically to New York

and Hollywood. For most American artists after 1945, Europe became a wonderful place to connect with the DNA of art history, but a destination more touristic than fundamental—an option rather than a requirement.

But history, even (and perhaps especially), art history, is always a stunningly counterintuitive site. If Gene Kelly/Jerry Mulligan had indeed looked carefully around him in Paris in 1951, he might have encountered another young artist named Kelly who was living, studying, and working there. Ellsworth Kelly, also a former soldier benefiting from the GI Bill of Rights, had arrived in France in 1948 and would remain in Europe until 1954. The impact of Kelly's extended sojourn in France on his career and vision has been the subject of several exhibitions. While the full ramifications of it are somewhat outside our concerns here, his incredible processing of French art and culture into elements for him to ponder extended in 1952 to Claude Monet and Giverny.

Monet's position as a major figure in the history of art is so secure today that it might come as a surprise that it was not always so. In the 1950s, Monet was certainly a well-known figure, but largely for the smaller-scale easel painting he had done in the nineteenth century, as a central player in the ascent of French Impressionism. His later and often more monumental work, centered on his home and gardens in Giverny, was less accessible, less popular with the public. Despite the presence (though not always on display) of a large diorama-like cycle of late water lily paintings at the Orangerie in Paris, much of Monet's late work remained unseen and in private hands, including the many canvases somewhat casually retained by his heirs. (The cycle at the Museum of Modern Art in New York was not acquired until 1959, replacing an earlier late Monet acquired in 1955 and destroyed by a fire at MoMA in 1958). Monet's overt influence on contemporary art was similarly occasional as the impulses of twentieth-century art led to greater interest in his contemporaries such as Cezanne, Van Gogh, and Gauguin. Whatever the lure of Giverny had been for artists in the late nineteenth and twentieth century, when Monet still walked its environs until his death in 1926, it had largely ceased to function as such by mid-century. The exaggerated tale that Monet had painted much of his late work in a state of near or complete blindness was also circulated to the detriment of his reputation. The Monet revival, which commenced in the 1950s, culminating in the acquisition of his later work by many museums and in critical reconsiderations of his position by writers such as Clement Greenberg, William Seitz, and Thomas Hess, began to secure the historical rehabilitation Monet enjoys today, with his work from Giverny especially prized as the fulfillment of his aesthetic, not as its dropping off.

In 1952 Ellsworth Kelly couldn't know that this was to come, of course. He had been intrigued by seeing a late Monet *Nymphéas* in Zurich and read in a book by Monet's friend and former French Prime Minister Georges Clemenceau that Monet had spent his final decades in Giverny. Kelly wrote to Monet's stepson, Jean-Pierre Hoschedé, and an invitation for Kelly to visit what was still a private residence in the little noted town of Giverny ensued. Kelly made the somewhat arduous trip in September 1952 (the closest train stopped in Vernon, on the other side of the Seine a few miles walk from Giverny) and was bowled over by the dozens of large, late canvases he saw there, many of them stored in the not-so-benignly neglected ruins of Monet's large glass studio. (Kelly has often commented on the disrepair he saw there, the broken windows, pigeons flying about, canvases stacked willy-nilly—including some suffering water damage—all an incredible example of the waning of Monet's reputation during this period.)

Kelly's response to the visual impact of Monet's late work was immediate (plate 38). In several paintings Kelly creates tonal canvases that subtly shift back and forth from green to blue, alluding to and absorbing the aqueous nature of late Monet, the poetic indeterminacy of water, plant, and sky. Visible brushwork, somewhat a rarity in Kelly's oeuvre, appears here in touched and textured surfaces that summon a bit of the sensuous slathering of late Monet, a similar indulgence in the oozing tactility of oil paint. But the deepest impact of Monet on Kelly's vision seems to be in the realm of pictorial structure, in the architectonics of painting, how integers of color over a two-dimensional surface can hover between evocations of flat pattern and hints of deep space. Kelly's thinking had been leading him toward the grid as a way of considering color and shape, reducing it to some kind of essence that offered possibilities of expansion rather than contraction. While Monet's immersion into the fecund glories of unabashed nature might seem antithetical to Kelly's aims, the means by which Monet achieved it, the control of long and sometimes extended horizontal canvases using recurring colors or stroke patterns to link the vista together into some kind of supra-nature,

interested Kelly. A grid could be a dappling grid, the logic of disciplined and sequential pixels of paint could be a scintillating logic, and colors could mean something by themselves and also allude to a distant echo of nature (plate 37). Monet played a small but critical role in Kelly's move toward a kind of synthesis, a more generous integration of the fundamentally two-dimensional nature of what painting is and the push/pull that historically had it allude to an actual three-dimensional world.

Joan Mitchell's engagement with Claude Monet and Giverny was certainly of longer standing than Ellsworth Kelly's (plates 49, 50). The latter spent about a day in Giverny; Mitchell would live in Vétheuil, a few miles away from Giverny, for nearly twenty-five years, many of them on the same site that Monet and his family inhabited from 1878 to 1883, just before his final move to Giverny. Mitchell's arrival in the Seine Valley and its inexorable proximity to Monet's turf was an interesting physical manifestation of what had already happened in an artistic and cultural way to her and many of her colleagues in the New York art scene. As Abstract Expressionism had become the signature style of postwar American art and artists such as Mitchell, Jackson Pollock, Willem de

Kooning, and Philip Guston began to articulate the ebullient and aggressive possibilities of bravura and bold brushwork applied in some kind of existential manifestation of personal emotion and strong feeling, the critics who supported and provided some of the intellectual underpinning for this movement began to posit likely historical prototypes for Abstract Expressionist activity. While the more contemporary Surrealists would be particularly privileged for their often giddy explorations into the possibilities of a pursuit of the subconscious or unconscious mind as a way of freeing up artistic impulses to achieve deeper, more fundamental truths, Monet, too, was cited as a possible model by writers such as Greenberg, Seitz, and Hess. In the mid-1950s in a magazine such as *ARTnews*, reproducing a late Monet *Water Lilies* painting—a seemingly surging and turbulent horizontal massing of strident and forceful brushstrokes, viscous and bold, appearing impetuous and passionate, as if created in a sudden burst of overwhelming energy, as if the brush couldn't move fast enough, the canvas as a record of a physical assault by a painter with the liberating freedom of rampant velocity primarily on his mind—juxtaposed with a reproduction of a painting by, say, Jackson Pollock, could prompt one to employ

almost precisely the same language when speaking of the Pollock.

The consideration of Monet as a great twentieth-century painter, not solely as the honored French Impressionist whose core work was of the 1870s and 1880s, was the most important contribution of the Monet revival of the 1950s. Of course, there were a few sticky points to overcome—while scholars and critics trumpeted Monet as a possible prototype for some tendencies in Abstract Expressionism, the artists themselves were largely silent about or indifferent to his work. And despite the critics' arguments that Monet's late work flirts with the absolute edges of representation and reaches a kind of pantheistic crescendo somewhere beyond the seen, many observers weren't having it. The term Abstract Impressionism was briefly touted as some kind of middle-ground gesture, a way of subtly linking Monet to those artists (Mitchell, for example, and Guston as well), whose work seemed more rooted in optical pleasure than in personal or diaristic expressionism, who celebrated the sensuous and lyrical beauty of color more than its overtly emotional employ.

At face value, Mitchell's move to Vétheuil and her purchase of property formerly owned by Monet seems a latter-day instance of the cultlike near stalking of Monet done by many American artists in the late nineteenth and early twentieth centuries. For those earlier travelers to Giverny, the prospect of encountering the living maestro did exist; Mitchell's action could be seen as a way of absorbing the milieu and environment of Monet now that he was no longer alive, a kind of channeling of his aura. But Mitchell herself always vociferously denied this. It is certainly true that her move to Vétheuil with her partner, the Canadian artist Jean-Paul Riopelle, was primarily motivated by their desire to find a place to live and work outside Paris, not by any specific interest in Monet. Once there, though, Mitchell—Riopelle, too, for that matter—began to respond forcefully to her physical environment. Indeed, as the title of this exhibition indicates, it is the lure of Giverny and its environs that seems to have operated on Mitchell, just as it had on Monet, her journey not in homage to a particular artist but in eventual tribute to a special place. Reading her work as a parallel encounter to Monet's, a rearticulation in the language of late twentieth-century painterly strategies of some similar concerns, may bring us closer to the truth here. The still rural beauties of the Seine Valley are celebrated in both artists'

work, a visual richness each parallels in his or her idiom. For Monet in his late paintings this entails some kind of an immersion into nature, a form of Dionysian surrender to bliss, a search for an immersive equivalence in oil paint to the life forces he felt swirling about him in his garden a few paces from his home. Mitchell seems less confident, less certain, about the possibilities of universal transcendence; her response is both more specific and more searching, a kind of muscular assertion of self, concentrating on constructing each painting as a painting, not as some parallel phenomenon to nature. Mitchell never disappears into nature as Monet seems to aspire to do; she retains perhaps the more contemporary sensibility that nature must be experienced by us through the body, through personhood, that we are always exterior to it, and are in our way yet another nature.

Mitchell did have a firsthand view of the incredible changes taking place in Giverny. Michel Monet, Claude Monet's youngest son and last surviving child, died in a car accident in 1966. His will left the Monet property in Giverny to the Académie des Beaux Arts, which took possession of the rather dilapidated grounds and several hundred paintings, many of which were transferred to the Musée Marmottan Monet in Paris, today

holder of the largest collection of Monet's work anywhere. The home, studio, and grounds in Giverny were slower to be appreciated or restored. Gerald van der Kemp, who had worked at the Louvre and served for twenty years as curator-in-chief at Versailles, where he supervised important restoration work, moved to Giverny in 1977 and spent the next three years working on the restoration of Monet's property, serving as its first director. In May 1980 the home and gardens opened to the public, vastly aided by the incorporation of the Claude Monet Foundation (a division of the Academie des Beaux Arts) and the particular largesse of American donors such as Lila Acheson Wallace and Walter Annenberg. The Claude Monet Foundation and the Versailles Foundation also began to sponsor residential studios for visiting artists, eventually on the grounds of Monet's home. Many of the younger artists in this exhibition made their journey to Giverny under the auspices of such philanthropic organizations. The Terra Foundation for American Art founded the Musee d'art Americain Giverny in 1992 and offered short-term academic residencies on site. Slowly but surely tourists began to make the trip to Giverny, often as a day-trip by bus from Paris (back and forth in five hours), touring

Monet's home and grounds. Vast sums were allotted to reconstruct the gardens to how they appeared during Monet's lifetime. (Indeed, in order to please the tourists the garden is far more lush far longer than it was during Monet's lifetime, as plants that only bloomed a few weeks each year while he was alive are now artificially rotated, bred, or raised in greenhouses to bloom all spring, summer and autumn.) All this has worked, possibly too well; today, a reported 400,000 people a year visit a village with a permanent population of about 550 (it was around 300 when Monet lived there). No paintings by Monet are exhibited at his home in Giverny; visitors experience less art than its setting, its context carefully recreated.

This infusion/invasion is startling, a testament to what can happen when one becomes universally recognized as an artist of stupendous stature. As part of the secularization of existence, sites connected to cultural and historical figures have come to augment or replace spiritual sites as places to visit. (Websites inviting visitors to Giverny are replete with terms such as pilgrimage, and call it a place of memory, of meditation and contemplation. The bus tours offer a quick side trip to Auvers-sur-Oise, where Van Gogh died, including a visit to his grave.) The quasi-idolatrous subtext of all

this, the sense of Giverny being presented as some secular Chartres, inevitably led to a kind of biographical sanitization of Monet himself. The hagiography of artists, tales told of their genius that still retain a sense of their humanity (like the one told of how Monet found himself unable to stop noting the subtle color changes in the face of his first wife as she lay dying) become part of that process, as the artist becomes as much a subject of devotion as the work he or she creates. Mark Tansey, an artist of consummate wit and intelligence, turned his attention to one of the core tales of the Monet saga in his 1994 painting *Water Lilies*. Determined to create a large pond on his property so as to plant the water lilies and build the Japanese bridge he would immortalize in the decades to come, Monet in 1893 applied for permission to divert water from the river Ru into a small pond that already existed on his property. His neighbors, mostly farmers who used the river (more of a stream, actually) for agrarian purposes and to water their livestock and wash their laundry, objected to this diversion, and the usual rancorous zoning to-and-fro ensued. Monet, by then a power in the community, became furious until he got his way, and twice more, in 1901 and 1910, additional river water was diverted to his pond.

The story shows Monet as a bit of a *grande seigneur* caught in a slightly ridiculous argument with his neighbors, seeking to manipulate nature to create a little ecosystem he could completely control. Thirty years of trudging around the French countryside had gotten old for Monet, and that this servant of nature could now become its master, that he could literally turn his property into a cottage industry, must have tickled the irreverent streak in Mark Tansey, who from time to time has turned his attention to art history as a particularly pompous and pretentious site overripe for deflating. He created his painting, rendered in his signature blue monochromatic palette, as a long horizontal diptych (plate 54), much like a late Monet. And like a late Monet, it is an aqueous image, a paean to icy water, to the reflections in its surfaces and to hints of what lays beneath those surfaces, and to the way water eddies and churns about when winter shifts to spring. At its very summit, Tansey renders a smallish reflection of the white-bearded Monet, like Moses at the Red Sea, as he cranks some large valve to open the sluice that will let the Ru flow into his pond, refreshing its volume. This is all made up in Tansey's imagination, of course, not based on any photographs or specific historical accounts. But if nearly half a

fig. 31
**EXTERIOR VIEW OF ARTISTS'
RESIDENCE AND STUDIOS, GIVERNY**

Courtesy of Yeardley Leonard

million people are visiting Giverny each year, are propagandistic history images, tongue in cheek or not, of its protagonist far behind? Tansey's is a bit of an in-house art historical joke, an allusion to a small part of the Monet saga here writ large, with the mundane made monumental. (Or is it? An alternate reading of the painting is that it depicts the 1910 flooding of the Ru and the nearby Epte rivers, and the seventy-year-old Monet's desperate effort to protect his pond from the vagaries of nature, trying to preserve his Xanadu for a little bit longer. But the painting's real subject seems the apotheosis of Monet, that anecdotal incidents become a kind of new dogma, that art history can become Art History, and that cult is literally part of culture.)

Unlike a century ago, when most visitors to Giverny were artists—almost all American— seeking Monet and/or his milieu, today the over-whelming majority of visitors are tourists wishing to experience the sources of the paintings they admire so greatly. But artists come as well, and for a wide variety of reasons. Part of the lure of Giverny today for artists is that it is a place where one can apply to win a fellowship to work and study for a predetermined length of time, usually running somewhere between three and six months, which will include room and board, studio space, and

101

fig. 32
**VIEW OF ALEXANDER ROSS
STUDIO, GIVERNY**
2000

Courtesy of the artist

fig. 33
**PAINT STIR STICKS, YEARDLEY
LEONARD'S STUDIO, GIVERNY**
1999

Courtesy of the artist

often a small honorarium or travel stipend (fig. 31). Typically such fellowships are for someone who is formed artistically but is still flexible and seeking opportunities to experience something new. These young artists often have a strong preference for where they would like to study, with a sense that some environment or context with particular connotations might be of special advantage. Usually major cities, major art centers are desired, where the opportunities to maximize one's time and absorb as much as possible seem clearest. But residencies are both very competitive and scattered all over the world, and an artist who wants to work in a smaller and more intimate place such as Giverny has clearly self-selected it as an environment conducive to his or her interests (fig. 32).

Most of the other nine contemporary artists in this exhibition experienced Monet and Giverny through this path. It is fair to note that, if artist residencies were not offered in Giverny, some of them might not have had the opportunity to engage its contexts so thoroughly, indicating a degree of difference between this generation of Giverny visitors and those of a century ago. Each of these—Will Cotton, Steve DiBenedetto, Dan Hays, Yeardley Leonard, Miranda Lichtenstein, Mary Lucier, Cameron Martin,

Alexander Ross, and Eric Wolf—have individual stories to tell of their experiences in Giverny or fascination with Monet—sometimes both—experiences that perhaps affirm a direction to which they were already leaning, or opening up a new horizon. Through their work, we can assess some aspects of the crucial issue at hand here: how is Monet and/or Giverny relevant to contemporary art practice today, how can we balance a sense of homage with a critical and investigative spirit, how can we give Monet meaning now? (Giverny is also visited by many historicist artists today, latter-day Impressionists who overtly wish to summon back the aura of, say, 1898, seeking some concept of a sylvan past as a release from the confusion and pressures of the present, believing that what we need to know about nature and Monet is contained within his work and echoing that work openhandedly. More contemporary spirits put things like that on trial and attempt to employ Monet as a way of thinking about current concerns, be they of nature, culture, celebrity. Monet and Giverny become signs, flexible phenomenon to be admired and questioned, tools to be put wherever possible to new uses.)

The intimate (in terms of both scale and mood) paintings of Yeardley Leonard, who had a

residency in Giverny in 1999, seem of this ilk, ways of evoking aspects of the structure and milieu of nature while not representing it in an observational manner (fig. 33). Her work both in and out of Giverny turns visual information about the exterior world into a personalized pictorial code, stunningly nuanced and more about what nature is than what nature looks like. She seeks some kind of equivalence and uses color and shape to walk the tightrope between abstraction and representation, finally suggesting that they can be very much the same thing (plates 41, 42; fig. 34). Dan Hays's paintings are also characterized by a kind of imposition of structure, an experiential grid, in his case specifically suggesting a vertical kind of video disintegration, as if images of nature, whether filtered through Monet or not, are as evanescent as nature itself, hovering between some meta-reality and memory (plates 35, 36). There is a kind of fragility operating here, an achievement of tenuousness that is both visual and psychological, alluding to the somewhat dislocating photographic roots of most of our encounters with Monet. Another kind of pattern marks Eric Wolf's incredibly rhythmic and ebullient images, with their source in a highly stylized process of transmogrification (plates 55, 56); everything gets churned

103

through his bulbous and cursive imagination into some up-tempo graphic mandala that sends the eye zipping about. His 1999 residency in Monet's garden is processed through his idiosyncratic approach, and offers a reading of Monet and his milieu as he almost never is characterized, as a linear artist and site of funky and flowing cadence.

Miranda Lichtenstein's rich and saturated photographs riff on the mystery of Giverny as colonized territory (plates 43, 44); she had a residency there in 2002, and later photographed a replica of its gardens in Kitagawa in Japan (plate 45; fig. 35). Lichtenstein avoids the celebrated views of Monet's gardens, the water lilies and bridge. Her subject is not Monet as much as it seems to be the more subtle one of how nature will win out, even when artificially staged for mass consumption as it is in Giverny today. Her plants and trees know not where they are, pursuing their own botanic ends, as we pursue our own process of interpreting them as heightened allegories of life. Mary Lucier's 1983 video *Ohio to Giverny: Memory of Light* (plate 46) also seems both celebratory and nostalgic, an intensely personal response to the poetics and poignancies of place. From her origins in Bucyrus, Ohio, to her travels to Giverny, Lucier's camera seems sun struck, vaguely disorienting, the

fragments of location and nature accumulating in an almost concussed manner, shards of memory that filter in and out of legibility, a kind of tone poem made visual, with Monet's subject matter drifting in and out of her rumi-nations. Cameron Martin, who had a residency in Giverny in 2001, also touches on a sense of defamiliarization in his paintings (plates 47, 48). There is little ambiguity about what Martin renders, images of trees or of water, but composition and color sometimes come together to offer something more mysterious than stable. A wonderfully patchy and monochromatic technique with ambiguous horizon lines makes his disembodied sylvan pools both completely readable as nature yet somehow disconnected from it, a state not unlike that achieved in Monet's late work.

Much about Giverny and the late work of Monet is about a kind of heightening, an intensification or embellishment of nature or of the artist himself. Will Cotton, who had a 2002 residency in Giverny, offers a similar indulgence in excess in his almost luridly saccharine images of dessert (plate 30). Sweets as desire, as a metaphor for self-indulgence and a guilty though universal pleasure zone, are celebrated in these purposefully cloying images. What a water lily is for Monet,

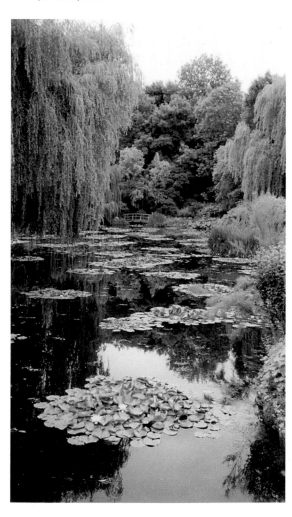

fig. 37
**LILY POND, SUMMER**
1999

Courtesy of Yeardley Leonard

fig. 38
ALEXANDER ROSS American, born 1960
**PHOTOMONTAGE OF GIVERNY
GARDEN PLANTS**
2000

Courtesy of the artist

105

a flan can be for Cotton, a vehicle inviting visual concentration that can activate senses in a viewer beyond those reached by text or language. Monet's gardens can be seen as nature's dessert, an extra reward created to celebrate its extremes, akin to Cotton's work. Steve DiBenedetto, who had his residency in Giverny in 1999, also evokes those last moments in Monet's work, when nature becomes less an observed thing than a felt and experienced force, a substance almost beyond knowledge and sight (plates 31–34). DiBenedetto's landscapes, with elements such as octopi or helicopters or Ferris wheels transcribed above and through them, take on this aura, sometimes apocalyptically, with swirling elements that seem to bring us to the brink of chaos. Somehow, though, as in late Monet, these reflect a mathematical or natural order within nature, even if an unstable order or one under stress, but still a universal reality within which the processes of life continue. If DiBenedetto and Monet touch on this theme in the macro sense, then Alexander Ross, whose sojourn in Giverny was in 2000, seems to experience it in the micro (plates 51–53). His images look like disembodied squiggles or loopy meandering abstractions, but they are rooted in direct observation of tiny snippets of nature. Close-up photography, even the

fig. 39
ALEXANDER ROSS American, born 1960
**PHOTOMONTAGE OF GIVERNY
GARDEN PLANTS**
2000

Courtesy of the artist

occasional use of a microscope, informs Ross as to the incredible drama of life at an intimate scale, how an inch of a denuded tree contains as much of the stew of life as a forest, if examined closely enough, the detail more than standing in for the whole (plates 51–53; figs. 38, 39). Fecundity and photosynthesis are rooted in the molecular, and Ross's pictures, though never created to be botanical documents, capture the essences that drive nature, and find the intense gaze at least as powerful as the expansive overview.

These artists all respond to the challenges of Giverny and Monet in their own way and arrived there with fundamentally different agendas than did the artists of a century and more ago. Unlike the American artists in the first half of this exhibition, those true acolytes and devotees whose focused fidelity to their maestro is writ large across their work, the contemporary artists seem intrigued by what they see and experience in Giverny, but can remain aloof from its status as hallowed art historical ground, unless, as a few do, they employ irony or psychological distance subtly to undercut it. It is no surprise to note, though, that all work two-dimensionally (nothing is impossible, but why would a sculptor seek a residency in Giverny?), as painters or graphic artists or video

artists or photographers with a rich visual palette, and almost all tend toward representational art in one vein or another.

It is almost a cliché of contemporary culture to speak of our disenfranchisement and alienation from nature, how our stewardship of our planet has been a mixed one, how we have come to function almost apart, rather than as a part, of and from nature. Giverny and the work of Claude Monet today can then become read as a site of nostalgia, as a constructed microsystem offering us a fabricated glimpse into a lost world, when an intense engagement with one's environment was still possible, perhaps even heroic. Like a lot of clichés there is some truth to this, but also some indistinct thinking. Monet's lifetime almost exactly transcribed the Industrial Revolution, from its origins to its collapse in the Great Depression. Railroad trains regularly passed near where he observed his garden and made his paintings, and the concept of Monet as some child of nature unaware of the modernity in his midst is a naïve one. Indeed, the argument could be made that his work is an affirmation of nature completely created as a response to its changing milieu, as an effort to insist on its pertinence as Arcadia, even if he had to construct it rather than discover or uncover it.

The challenge that confronts artists and visitors today isn't all that different, though Arcadia is now usually constructed internally rather than glimpsed externally. While Monet achieved a kind of certitude and conviction that many artists today no longer find to be possible, his search to do so remains a compelling one, and one that will change but not disappear for every subsequent generation. How to make Monet matter, in the largest sense of that concept, continues to be a part of contemporary art, in or out of Giverny, and exhibits every evidence of continuing to do so into the future.

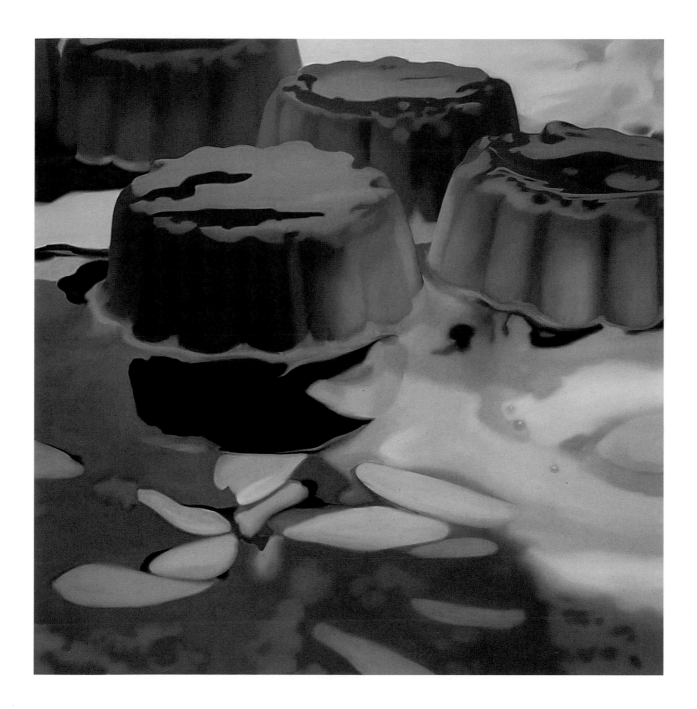

plate 30

WILL COTTON, **FLANPOND**, 2002

Oil on linen; 71 x 71 inches

Private Collection, New York. Courtesy: Mary Boone Gallery, New York

110

plate 31

STEVE DIBENEDETTO, **APOCALYPSE BROWN**, 1999

Oil on canvas; 20 x 26 inches

Collection of Sara and John Shlesinger, Atlanta, Georgia

112

plate 32

STEVE DIBENEDETTO, **CELTIC FROST**, 1999

Oil on linen; 11 x 14 inches

Collection of Geoffrey Young, Great Barrington, Massachusetts

plate 33

STEVE DIBENEDETTO, **ENVELOPE**, 1999

Oil on linen; 16 x 20 inches

Collection of Sara and John Shlesinger, Atlanta, Georgia

plate 34

STEVE DIBENEDETTO, **WHEN + WHERE**, 1999–2002

Oil on canvas; 18 x 24 inches

Collection of Kevin Bruk, Miami, Florida

116

plate 35

DAN HAYS, **DETERIORATION**, 1999

Oil on canvas; 35½ x 47¼ inches

Collection Galerie Zürcher, Paris, France

plate 36

DAN HAYS, **REFLECTION TRANSMISSION**, 1999

Oil on canvas; 35½ x 47¼ inches

Collection Bernard and Gwenolée Zürcher

plate 38

ELLSWORTH KELLY, **TABLEAU VERT**, 1951

Oil on canvas; 29 x 39 inches

Private Collection

© Ellsworth Kelly

plate 39

YEARDLEY LEONARD, **GIVERNY**, 2000

Acrylic on canvas; 16½ x 20 inches

Private Collection

plate 40

YEARDLEY LEONARD, **VERNONNET**, 2000
Acrylic on canvas; 16½ x 20 inches
Collection of A. G. Rosen

plate 41

YEARDLEY LEONARD, **IN THE GARDEN**, 2004
Acrylic on canvas; 24 x 18 inches
Collection Christopher Hamick, New York, New York

plate 42

YEARDLEY LEONARD, **WAIT FOR ME**, 2004
Acrylic on canvas; 27⅛ x 22 inches
Collection Isabel Rose, New York, New York

plate 43

MIRANDA LICHTENSTEIN, **AFTERNOON**, 2002
C-print; 48 x 60 inches
Courtesy of the artist, Elizabeth Dee, New York, and Mary Goldman Gallery, Los Angeles

plate 44

MIRANDA LICHTENSTEIN, **COIL**, 2002
C-print; 38 x 30 inches
Courtesy of the artist, Elizabeth Dee, New York, and Mary Goldman Gallery, Los Angeles

plate 45

MIRANDA LICHTENSTEIN, **PERENNIAL**, 2003
C-print; 23⅜ x 18 inches
Courtesy of the artist, Elizabeth Dee, New York, and Mary Goldman Gallery, Los Angeles

plate 46

MARY LUCIER, **OHIO TO GIVERNY: MEMORY OF LIGHT**, 1983

Single channel video transferred to DVD, 3 stills, 19 minutes with sound

Courtesy of Lennon, Weinberg Gallery, New York, New York

plate 47

CAMERON MARTIN, **LOSS LEADER**, 2002
Oil and alkyd on canvas; 60 x 72 inches
Collection Warren Lichtenstein

140

plate 48

CAMERON MARTIN, **STUDY FOR UPDATE**, 2003

Oil and alkyd on canvas; 40 x 53 inches

Collection of Sheri Levine

plate 49

JOAN MITCHELL, **HEEL, SIT, STAY**, 1977

Oil on canvas, diptych; 110 x 126 inches overall

Joan Mitchell Foundation, New York, New York

© The Estate of Joan Mitchell

144

plate 50

JOAN MITCHELL, **RIVIÈRE**, 1990

Oil on canvas, diptych; 110¼ x 157½ inches overall

Joan Mitchell Foundation, New York, New York

© The Estate of Joan Mitchell

plate 51

ALEXANDER ROSS, **UNTITLED**, 2000

Oil on canvas; 69 x 88 inches overall

Collection of A. G. Rosen

plate 52

ALEXANDER ROSS, **UNTITLED**, 2000

Graphite and color pencil on paper; 18 x 15 inches

Donald Rothfeld, MD

plate 53

ALEXANDER ROSS, **UNTITLED**, 2000

Graphite and color pencil on paper; 18 x 15 inches

Donald Rothfeld, MD

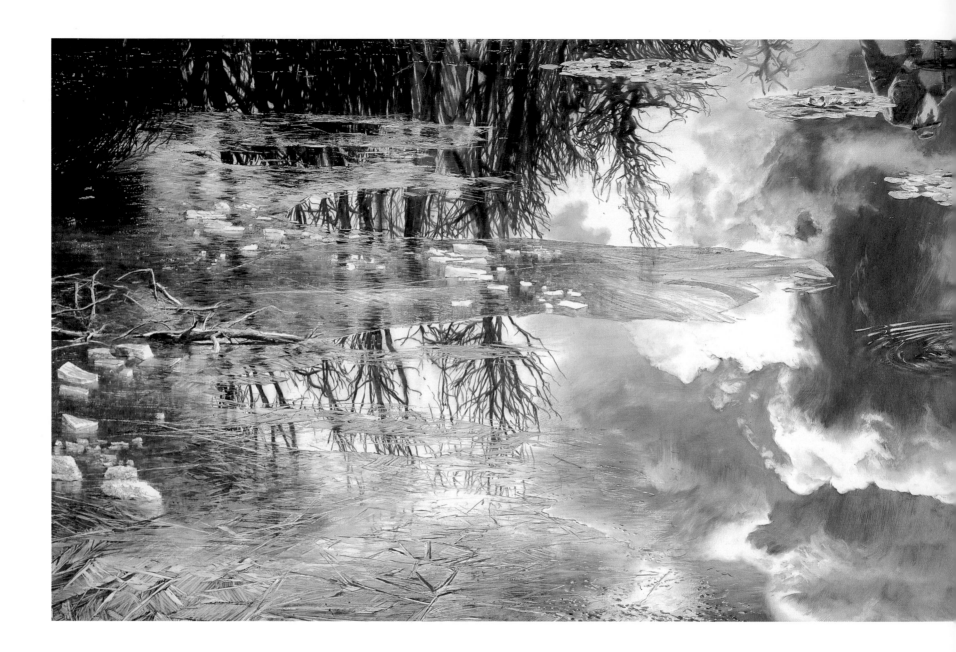

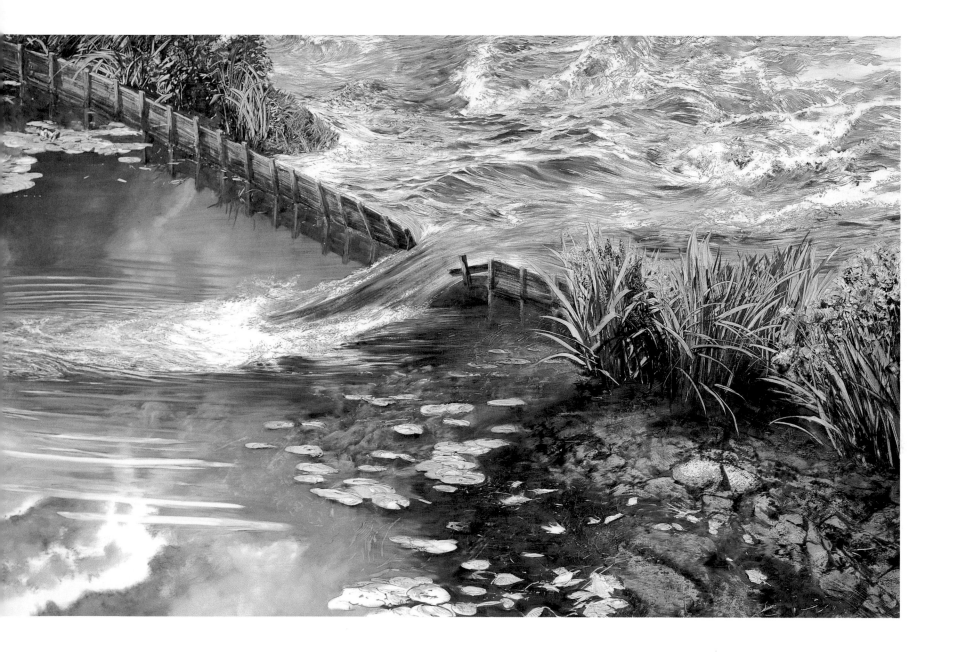

153

plate 54

MARK TANSEY, **WATER LILIES**, 1994
Oil on canvas, diptych; 60 x 192 inches overall
Columbus Museum of Art, Ohio: Museum Purchase, Derby Fund. 1994.009
© Mark Tansey

plate 55

ERIC WOLF, **JAPANESE BRIDGE AND NYMPHÉAS**, 1999

Ink on paper; 44 x 39 inches

Collection of the artist

plate 56

ERIC WOLF, **MONET'S GARDEN**, 1999

Ink on paper; 43½ x 36¾ inches

Private Collection, New York, New York

# Exhibition Checklist

**CLAUDE MONET**

French, born 1840, Paris, France; died 1926, Giverny, France

*Champs d'iris jaunes à Giverny* (Field of Yellow Irises at Giverny), 1887
Oil on canvas
17¾ x 39⅜ inches
Musée Marmottan Monet, Paris, France: Michel Monet Bequest, 1966

*The Seine near Giverny, Morning Mists*, 1897
Oil on canvas
35 x 36 inches
North Carolina Museum of Art, Raleigh, North Carolina: Purchased with funds from the Sarah Graham Kenan Foundation and the North Carolina State Art Society (Robert F. Pfifer Bequest). G.75.24.1

*The Artist's Garden at Giverny*, 1900
Oil on canvas
31⅞ x 36¼ inches
Paris, Musée d'Orsay, acquise par dation, 1982

*Nymphéas (Water Lilies)*, 1903
Oil on canvas
35 x 39½ inches
Musée Marmottan Monet, Paris, France: Michel Monet Bequest, 1966

*Nymphéas, Reflets de saule* (Water Lilies, Willow Tree Reflections), circa 1916
Oil on canvas
78¾ x 70⅞ inches
Musée Marmottan Monet, Paris, France: Michel Monet Bequest, 1966

*Nymphéas* (Water Lilies), circa 1917
Oil on canvas
39⅜ x 118⅛ inches
Musée Marmottan Monet, Paris, France: Michel Monet Bequest, 1966

*Wisteria*, 1919–20
Oil on canvas
59⅛ x 78¾ inches
Allen Memorial Art Museum, Oberlin College, Ohio; R. J. Miller, Jr., Fund, 1960

*Le Pont japonais* (The Japanese Bridge), circa 1918
Oil on canvas
35 x 45⅝ inches
Musée Marmottan Monet, Paris, France: Michel Monet Bequest, 1966

*Le Pont japonais* (The Japanese Bridge), circa 1918
Oil on canvas
29⅛ x 36¼ inches
Musée Marmottan Monet, Paris, France: Michel Monet Bequest, 1966

*Weeping Willow*, 1918
Oil on canvas
51⅝ x 43⁷⁄₁₆ inches
Columbus Museum of Art, Ohio: Gift of Howard D. and Babette L. Sirak, the Donors to the Campaign for Enduring Excellence, and the Derby Fund. 1991.001.041

*L' Allée des rosiers* (The Path Under the Rose Arches), circa 1920
Oil on canvas
35⅜ x 36¼ inches
Musée Marmottan Monet, Paris, France: Michel Monet Bequest, 1966

*La Maison vue du jardin aux roses* (The House Viewed from the Rose Garden), circa 1922
Oil on canvas
31⅞ x 36¼ inches
Musée Marmottan Monet, Paris, France: Michel Monet Bequest, 1966

**BLANCHE HOSCHEDÉ MONET**

French, born 1865; died 1947, Giverny, France

*House of Claude Monet*, circa 1926–28
Oil on canvas
23¾ x 32⅛ inches
Private Collection

**ALBERT ANDRÉ**

French, born 1869, Lyon, France; died 1954, Gard, France

*Portrait of Claude Monet*, 1922
Oil on canvas
52¼ x 36½ inches
Frederic Bouin, New York, New York

**KARL ANDERSON**

American, born 1874, Oxford, Ohio; died 1934, Westport, Connecticut

*The Idlers*, August, 1909
Oil on canvas
49¾ x 51⅝ inches
Brauer Museum of Art, Valparaiso University: Gift of Percy H. Sloan (53.01.109)

**JOHN LESLIE BRECK**

American, born 1860, near Hong Kong; died 1899, Boston, Massachusetts

*Garden at Giverny*, between 1887–91
Oil on canvas
18 x 21⅞ inches
Terra Foundation for American Art, Chicago, USA, 1999.18

*Yellow Fleurs-de-Lis*, 1888
Oil on canvas
17⅞ x 21⅞ inches
Terra Foundation for American Art, Chicago, USA, 1989.2

*Giverny Winter*, 1889
Oil on canvas
14 x 18 inches
Carnegie Museum of Art, Pittsburgh, Pennsylvania: Given anonymously in honor of the late Adolph W. Schmidt, 2000.51.1

**THEODORE BUTLER**

American, born 1861, Columbus, Ohio; died 1936, Giverny, France

*Entrance to the Garden Gate*, 1898
Oil on canvas
28 x 23 inches
Private Collection

*On the Seine*, 1902
Oil on canvas
31½ x 31½ inches
Private Collection

*Cottage at Giverny*, 1907
Oil on canvas
23½ x 28 inches
Private Collection

**FREDERICK FRIESEKE**

American, born 1874, Owosso, Michigan; died 1939, Paris, France

*The Garden Umbrella*, 1910
Oil on canvas
32⁵⁄₁₆ x 32⁵⁄₁₆ inches
Telfair Museum of Art, Savannah, Georgia: Bequest of Elizabeth Millar (Mrs. Bernice Frost) Bullard. 1942.7

**WILLARD METCALF**

American, born 1858, Lowell, Massachusetts; died 1925, New York, New York

*Spring Landscape, Giverny*, 1887
Oil on canvas
19½ x 25¾ inches
Collection of the Butler Institute of American Art, Youngstown, Ohio

**LILLA CABOT PERRY**

American, born 1848, Boston, Massachusetts; died 1933, Hancock, New Hampshire

*A Stream Beneath Poplars*, circa 1890–1900
Oil on canvas
25¾ x 32 inches
Hunter Museum of American Art, Chattanooga, Tennessee, Gift of Mr. and Mrs. Stuart P. Feld

**LOUIS RITMAN**

American, born 1889, Russia; died 1963, Chicago, Illinois

*Nude, Study No. 1*, 1915
Oil on canvas
36½ x 36½ inches
Des Moines Art Center Permanent Collections; Gift of Florence Carpenter, 1941.4

**THEODORE ROBINSON**
American, born 1852, Irasburg, Vermont; died 1896, New York, New York

*Afternoon Shadows*, 1891
Oil on canvas
18¼ x 21⅞ inches
Museum of Art, Rhode Island School of Design, Providence, Rhode Island: Gift of Mrs. Gustav Radeke 20.206

*By the Brook*, circa 1891
Oil on canvas
18 x 23⅜ inches
Collection of the Montclair Art Museum, Montclair, New Jersey: Gift of William T. Evans. 15.39

*La Débâcle*, 1892
Oil on canvas
18 x 22 inches
Scripps College, Claremont, California. Gift of the General and Mrs. Edward Clinton Young, 1946

**THEODORE WENDEL**
American, born 1857, Cincinnati, Ohio; died 1932, Ipswich, Massachusetts

*Girl Fishing, Giverny*, circa 1887
Oil on canvas
16¼ x 19½ inches
Mr. Whitney B. Wendel

**WILL COTTON**
American, born 1965, Melrose, Massachusetts

*Flanpond*, 2002
Oil on linen
71 x 71 inches
Private Collection, New York. Courtesy: Mary Boone Gallery, New York

**STEVE DIBENEDETTO**
American, born 1958, Bronx, New York

*Apocalypse Brown*, 1999
Oil on canvas
20 x 26 inches
Collection of Sara and John Shlesinger, Atlanta, Georgia

*Celtic Frost*, 1999
Oil on linen
11 x 14 inches
Collection of Geoffrey Young, Great Barrington, Massachusetts

*Envelope*, 1999
Oil on linen
16 x 20 inches
Collection of Sara and John Shlesinger, Atlanta, Georgia

*When + Where*, 1999–2002
Oil on canvas
18 x 24 inches
Collection of Kevin Bruk, Miami, Florida

**DAN HAYS**
British, born 1966, Kingston-Upon-Thames, England

*Deterioration*, 1999
Oil on canvas
35½ x 47¼ inches
Collection Galerie Zürcher, Paris, France

*Reflection Transmission*, 1999
Oil on canvas
35½ x 47¼ inches
Collection Bernard and Gwenolée Zürcher

**ELLSWORTH KELLY**
American, born 1923, Newburgh, New York

*Study for Seine*, 1951
Ink and pencil on paper
4¾ x 14⅞ inches
Private Collection
© Ellsworth Kelly

*Tableau Vert*, 1951
Oil on canvas
29 x 39 inches
Private Collection
© Ellsworth Kelly

**YEARDLEY LEONARD**
American, born 1969, New York, New York

*Giverny*, 2000
Acrylic on canvas
16½ x 20 inches
Private Collection

*Vernonnet*, 2000
Acrylic on canvas
16½ x 20 inches
Collection of A. G. Rosen

*In the Garden*, 2004
Acrylic on canvas
24 x 18 inches
Collection Christopher Hamick, New York, New York

*Wait for Me*, 2004
Acrylic on canvas
27⅛ x 22 inches
Isabel Rose, New York, New York

**MIRANDA LICHTENSTEIN**
American, born 1969, New York, New York

*Afternoon*, 2002
C-print, AP2
48 x 60 inches
Courtesy of the artist, Elizabeth Dee, New York, and Mary Goldman Gallery, Los Angeles

*Coil*, 2002
C-print, AP1
38 x 30 inches
Courtesy of the artist, Elizabeth Dee, New York, and Mary Goldman Gallery, Los Angeles

*Perennial*, 2003
C-print, Edition 4 of 5
23⅜ x 18 inches
Courtesy of the artist, Elizabeth Dee, New York, and Mary Goldman Gallery, Los Angeles

**MARY LUCIER**
American, born 1944, Bucyrus, Ohio

*Ohio to Giverny: Memory of Light*, 1983
Single channel video transferred to DVD, 19 minutes with sound
Courtesy of Lennon, Weinberg Gallery, New York, New York

**CAMERON MARTIN**
American, born 1970, Seattle, Washington

*Loss Leader*, 2002
Oil and alkyd on canvas
60 x 72 inches
Collection Warren Lichtenstein

*Study for Update*, 2003
Oil and alkyd on canvas
40 x 53 inches
Collection of Sheri Levine

**JOAN MITCHELL**
American, born 1925, Chicago, Illinois; died 1992, Paris, France

*Heel, Sit, Stay*, 1977
Oil on canvas, diptych
110 x 126 inches overall
Joan Mitchell Foundation, New York, New York
© The Estate of Joan Mitchell

*Rivière*, 1990
Oil on canvas, diptych
110¼ x 157½ inches overall
Joan Mitchell Foundation, New York, New York
© The Estate of Joan Mitchell

**ALEXANDER ROSS**
American, born 1960, Denver, Colorado

*Untitled*, 2000
Oil on canvas
69 x 88 inches overall
Collection of A. G. Rosen

*Untitled*, 2000
Graphite and color pencil on paper
18 x 15 inches
Donald Rothfeld, MD

*Untitled*, 2000
Graphite and color pencil on paper
18 x 15 inches
Donald Rothfeld, MD

**MARK TANSEY**
American, born 1949, San Jose, California

*Water Lilies*, 1994
Oil on canvas, diptych
60 x 192 inches overall
Columbus Museum of Art, Ohio: Museum Purchase, Derby Fund. 1994.009
© Mark Tansey

**ERIC WOLF**
American, born 1960, Hackensack, New Jersey

*Japanese Bridge and Nymphéas*, 1999
Ink on paper
44 x 39 inches
Collection of the artist

*Monet's Garden*, 1999
Ink on paper
43½ x 36¾ inches
Private Collection

# Illustration Credits

figs. 2, 9, 16, 21, 25, 28 Photo by Jacques Faujour

fig. 3 © Allen Memorial Art Museum, Oberlin College, Ohio

fig. 4 © Musée d'Orsay, Paris, France/Lauros/Giraudon. Image courtesy of the Bridgeman Art Library

plates 1, 4, 5, 6, 8, 9, 11, 12 © Musée Marmottan Monet, Paris, France. Image courtesy of The Bridgemean Art Library

plate 14 Photograph courtesy of Sotheby's, New York, New York

fig. 10, 12 Photograph © 2007 Museum of Fine Arts, Boston

fig. 6 Copyright © 2000 Condé Nast Publications, Inc.

fig. 11 © Tate, London

fig. 14 © Virginia Museum of Fine Arts. Photography by Katherine Wetzel

fig. 17 Philadelphia Museum of Art, Philadelphia, Pennsylvania. Photography by Lynn Rosenthal, 1995

fig. 19 © Photo Studio SÉBERT

fig. 26 © 2006 Bonhams & Butterfields Auctioneers Corp. All Rights Reserved

plate 15 © Brauer Museum of Art, Valparaiso University

plates 16, 17, figs. 18, 20, 23, 24, 27 © Terra Foundation for American Art, Chicago/ ArtResource, NY

plate 26 Photography by Cathy Carver

fig. 30 © Turner Entertainment Co. A Warner Bros. Entertainment Company. All Rights Reserved

plate 37 Photo by David Matthews, Harvard University Art Museums

plate 38 Photo by Jerry L. Thompson

plate 53 Photography by Oren Slor. Courtesy of Feature, Inc., New York

160